D0522523

200
phototips

By
Günter Spitzing

Translated by Mike Shields for
Cave Translations Ltd, London

FOUNTAIN PRESS
Argus Books, Watford, Herts, England

A Fountain Press Photobook

ISBN 0 85242 507 4

Argus Books Ltd,
14 St James Rd,
Watford,
Herts,
England

Printed Offset Litho in Great Britain by
Cox & Wyman Ltd, London, Fakenham and Reading

Contents

Exposure	1–8
Outside shots	9–23
Black-and-white photos	24–29
Colour photos	30–47
Filters	48–58
Portraits	59–72
Groups	73–77
Action photos	78–86
Scenic photos	87–99
Holiday photos	100–121
Interchangeable lenses	122–131
Flash	132–160
Photoflood	161–166
Close-ups	167–176
Projection	177–189
Sound	190–200

Exposure

There are few problems in photography that cause as much argument as those concerned with exposure. Some place their faith in automatic cameras, where the built-in exposure meter makes all necessary adjustments. Some prefer to use a manual camera with a separate light meter, while others go for semi-automatics.

The choice between these different methods is largely one of personal taste. Whatever your own approach, the following tips will help you get your exposures right, in difficult conditions as well as in normal light.

Calibration of the exposure meter

If you use black-and-white film, you can be sure that 95% of your pictures will be fine, because of the great latitude of such film. This would be true even if the exposure meter, whether built into the camera or separate, were up to one-third in error. Colour film, however, has less latitude, and this is particularly true of slide film. For this reason you may want to make a once-for-all test with your meter. Put a test film in the camera and take two or three different pictures, say, a landscape, a portrait, and a still life. In each case, take one exposure exactly as indicated by the meter, followed by two more, one of these at one stop less, and one at one stop more, than indicated. The results will show if any adjustment is necessary.

Exposure correction in automatic cameras

Some automatics will allow you to override the control system and take photographs manually. Others have a regulating button which opens or closes the diaphragm by up to one complete stop. The majority of automatics will allow you to offset the exposure by one or two stops above or below the set value. In the manual mode, you might need to open the lens one stop for a back-lit subject, or stop down one stop if the subject is surrounded by a large, dark background.

Low-contrast subjects

Themes with little contrast, where the lighting is flat or the colours are of matching tone, are easily dealt with in black-and-white as the prints can be made on a contrasting grade of paper. With colour film it is often best to under-expose a little, not more than half a stop at most, as this will ensure strong, fully saturated colours. Colour negative film, on the other hand, could benefit from a fraction more exposure. Pictures containing a great deal of snow, or taken from the air, will benefit from half a stop extra exposure.

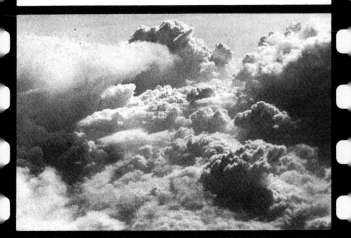

High contrast

This is exactly the opposite of the previous case. A zebra, to take an extreme example, frontally illuminated with direct sunlight, will pose far greater problems of contrast than a white horse in similar circumstances. Here a very precise exposure is needed, because even a small error on the high side will over-expose the light areas, while a small error the other way will make the shadows too dark. Bear in mind that negative films do not allow excessive over-exposures – at medium apertures – although reversal films are tolerant of exposure errors. So, for negative films, take your measurements on the shadows, and on the high-lights for reversal film.

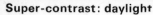

Super-contrast: daylight

Subjects taken in sunlight have the highest contrasts and, consequently, the rules for contrasting subjects apply more strongly. With reversal film, the aperture should normally be set one stop lower than that given by the exposure meter. Of course, there are exceptions to this rule. For example, in photographing a girl with back-lighting, the face will come out too dark unless fill-in flash or white reflector is used. However, over-exposure of the outline will give an interesting halo effect in the hair. Negative film always allows slight over-exposure.

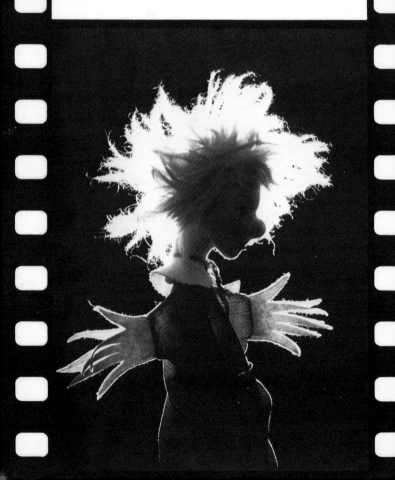

With back-lighting, contrast is greatly increased when the sun is reflected from bright surfaces, as with this lake near Kiruna, in Swedish Lapland.

Back-lighting on the hair of a puppet, which gives a silhouette-type effect. In this case the over-exposure is multiplied by a factor of four, so as to illuminate the face, which is in shadow.

Source of illumination (sun)	Frontal illumination	Lateral illumination	Back-lighting

6

Measurement of the foreground

The most common error made in measuring exposures is that of allowing too much light into the camera. Whether blue or overcast, the sky is usually much brighter than the scenery. If the light meter is pointed at the scenery including an expanse of bright sky, the foreground will be under-exposed and come out too dark. To overcome this difficulty, you should measure only the foreground of the subject. Take an average of well-lit foreground areas near the camera. In certain types of automatic camera, this has to be done as follows: point the camera at the foreground detail; depress the button enough to hold the automatic exposure control; with the finger still on the button, point the camera at the subject and then take the photo.

7

Incident light measurement

The light meter is usually directed towards the subject, and therefore measures reflected light. There are also light meters which have an opal disc set in front of the cell. These are placed in front of the subject and pointed at the camera to measure the amount of light falling on the subject. With this method, it doesn't matter whether the subject is light or dark, and it is therefore especially suitable for subjects which have very dark or very bright areas in them, as the reading will be correct for middle (skin) tones.

8

Exposure measurements using a grey card

If your subject is too far away, or has very bright or very dark colours, you can still get good results by using a substitute. For this, professionals use a special grey card. However, you can get a similar effect with a tile of neutral grey colour, the palm of a hand, or a sheet of newspaper (the combination of white paper and black print gives almost exactly the right shade of grey). It is important that the grey card is illuminated to the same extent as the subject is. This type of measurement is done in the same way as foreground measurement, as described in **6** above.

Outside shots

Now we're going to give you some tips which apply whether you're using black-and-white or colour. Always remember that, in a photograph, the subject itself is not the only thing of importance: the background can make a great difference to the result.

Get as close as possible

The vast majority of photographs are taken from long distances. This is natural with landscapes, of course, because of the separation from the subject. But there are also photos of people, animals, trees, monuments, fountains, and everything else you can get in front of the view-finder of a camera.

Do yourself a favour — get close up! Get as close as you can! Maybe your friends take pictures of people and animals from a distance of 10 or 15m, but don't imitate them. Take your photos from no more than 2–3m. Only in this way will they have sufficient impact.

Short exposure times

With non-automatic cameras, one is usually advised to keep exposure times no greater than 1/30sec. If you limit the enlargement of your prints to a maximum of postcard size, this recommendation is probably good enough. However, black-and-white photographs don't really give an impression of realism unless they are enlarged to at least 18×24cm. At such enlargements, the photo must be absolutely sharp, and so the figure recommended above must be reduced to about 1/125 or 1/250sec. The well-known rule of 'f/11 and 1/30 for exteriors in summer, with natural light' doesn't work in these cases. Colour slides don't require a great degree of sharpness, and can therefore be exposed at 1/60 or even at 1/30sec if necessary.

Holding the camera still

A short exposure time naturally dictates favourable lighting conditions. If you can't arrange this, get the camera set as firmly as possible. A tripod is obviously best but, if one is not available, any firm support for your elbows — for example, the shoulders of a helper — will be better than nothing. This method allows times of up to $\frac{1}{8}$sec, if you're careful. But even with short exposures, some blurring will occur if there is violent movement in the subject, as there is with sport.

Country market in Andraitsos (Greece). Below 1/125sec hand-held. Right: 1/15, hand-held with elbows braced on balcony railing.

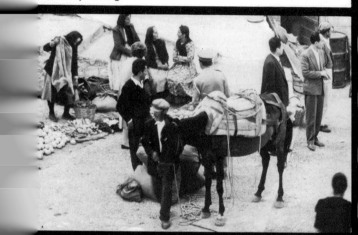

Direction of movement and sharpness

If the subject is moving towards the camera, it is possible to photograph it more or less sharply at relatively slow exposure times. But if this same subject is moving across the field of vision, the exposure time must be shortened by at least two values. Thus a time of 1/125sec might have to be reduced to 1/500. Whether a fast-moving car will appear sharp depends on its distance from the camera. At more than about 50m, the vehicle will be quite sharp, but at less than 15m it will be very blurred. This can, however, give a very interesting motion effect.

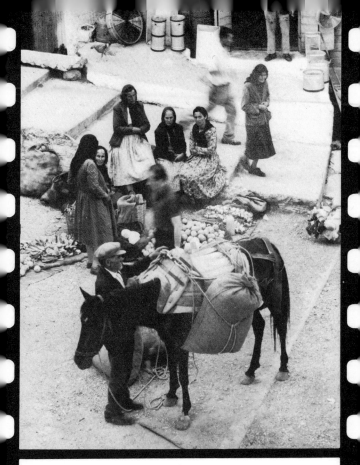

Panning

Suppose we have to work at slow exposure times (1/30 to 1/25 sec), either because we have a camera which will give only those speeds or because of adverse lighting conditions. In either case, we can still get sharp photographs of moving objects by 'panning' the camera. This means that the camera is swung round to follow the moving object throughout the duration of the exposure. With a little luck, you will get sharp images of moving subjects such as aeroplanes or speedboats, although the background and surroundings will be blurred. However, because of this the photo will give a convincing impression of rapid motion.

First of all — measure the light

Obviously, being 'quick on the draw' is vital with action photos. Many good shots are missed because of the need to set aperture and exposure time. This is one of the points in favour of automatic cameras. However, still subjects, such as landscapes or portraits, are easily taken with semi-automatic or manual cameras. Whatever your camera, you can still be ready if you measure the light in advance. As soon as you go out with your camera, measure the ambient light and set your aperture and shutter speed accordingly, leaving it ready for immediate use. If you check it every hour or so, you won't miss an unexpected action shot.

Distance between subject and background

It is not advisable to have too short a distance between the main subject situated in the main plane of a photograph — a pretty girl, for instance — and the background. In photographs which cram into a single plane all the diverse subject matter which has been included, the distance between the main plane and the background tends to look less than it does in real life. Because of this, a person placed near a tree, a wall or a railing, looks as if he is part of it. Oddly enough, many photographs are shot in just this way, so that you can get the curious optical effect of, say, a lamp-post rising directly out of the head of your subject. So note well: plenty of space between the main plane and the background.

Use the widest possible aperture

I know a lot of owners of excellent cameras who take everything at f/11 so that everything will turn out sharp. In this way, the effectiveness of their expensive equipment is reduced to that of a box camera. Certainly, there are many situations in which it is not necessary to pay much attention to aperture. You need a fixed depth of field in photographing, for example, a sailing boat coming towards the camera, where both fore and aft ends must be in focus. At a distance of 4m this might need exactly f/11. Bear in mind, however, that great artistic effects can be achieved by having only parts of the photo in focus. The greater the contrast between the main subject and the background, the more it stands out from it.

Depth of field

With the diaphragm wide open, the depth of field is reduced and hence the zone of sharpness in your photograph will be much less; again, with the aperture stopped down, the depth of field and hence the zone of sharpness will be increased. You must also take account of the fact that whatever the aperture, there is a greater zone of sharpness behind the exact point of focus than in front of it (approximately double). So, if you are taking a car from the front, focus just beyond the front of the vehicle so as to get the whole of the car sharp.

With the diaphragm wide open, the depth of field is restricted to a narrow zone. The cat and one of its kittens appear sharp in this photograph, and stand out from the other planes of the picture.

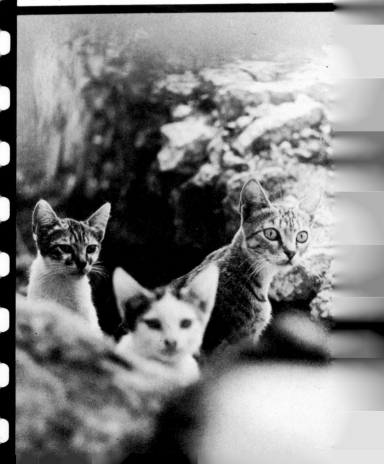

Camera angle

With action photographs in the majority of cases you have to react in a fraction of a second. It is difficult, therefore, to arrange a suitable background. It is always worthwhile glancing right and left just to see if there is anything suitable to use as a backdrop. However, the really decisive change is produced when you use the sky as a backdrop, or when you snap from above. Certainly, a high or low camera angle can give extra dramatic effect to your photographs.

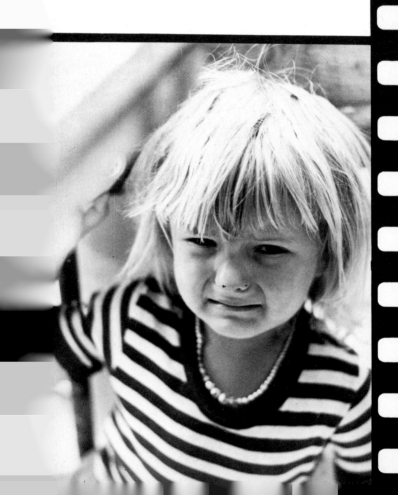

Train yourself to estimate distances

There is a certain apprehension attached to using wider apertures. This is the fear of not being able to set the distance accurately, thereby obtaining an out-of-focus image.

It is by no means easy at, for example, f/2.8 or f/2 to estimate distances with sufficient accuracy for sharpness. It is best, of course, if you happen to have a camera with a built-in range-finder or a reflex. I personally recommend equipment with this feature built in, since the greater aperture of the lens allows the use of f/4 or more. In other cases, you must train yourself in the estimation of distances, especially in the 1–3m range. (Check your estimates with a pocket tape-measure.)

Can I photograph in bad weather?

The general opinion that brilliant sunshine produces the best photos is based on a major error. It must be admitted, of course, that landscapes and panoramas don't come out so well if the sky is covered with a thick layer of cloud. Portraits, on the other hand, can be very much better in poor weather than when the sun shines brilliantly out of a clear sky. A wide aperture allows you to take your photographs in bad weather. (In most cases, the 'bright sun' position is marked with a sun symbol, and the 'cloudy' setting with a cloud.)

This little girl is unhappy. Her mood is as sombre as the weather was when this photo was taken. But it is precisely this that makes the photo so attractive. All the facial detail is uniformly illuminated. With cloudy skies you don't get the dark shadows around nose and eyes which so often spoil portraits taken in bright sun.

Don't always shoot with frontal lighting

As you will realize, frontal illumination produces a pretty monotonous effect. Side-lighting, especially when softened by cloud, or also back-lighting, emphasizes the spatial effect in the lens. In some cases, the high midday sun gives as bad an effect with scenery as it does with portraits. The illumination produced by frontal sun is little better in colour, either. This must be stressed because there are people who will tell you the opposite.

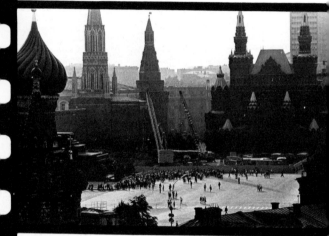

A telephoto shot of Red Square in Moscow with back-lighting (Leicaflex SL with Elmarit-R lens). Because of the great distance, the contrast is somewhat softened by haze.

The contrast of light and shade gives this photo a special charm. The luminous contours make the child stand out against the background.

Back-lighting as a form of illumination

Photographs with backlighting have a special grace when the sun is low. In the late evening, you can even photograph against the sun. However, if the sun is bright enough to make you squint, then it is better not to point the camera directly at it. Try to arrange that the sun is behind the trunk of a tree, or a church steeple, or something like that, or use a screen of leaves to moderate its direct rays.

Watch out, however, for reflections; the sparkle from the surface of leaves, from glittering fragments of rock, the glaze from wet roads, and especially from water — lakes, rivers, pools and so on; also, of course, from windowpanes. Subjects lit from behind acquire a fantastic aspect. Flowers, leaves, stained-glass windows and street-lights have a particularly beautiful effect in colour slides.

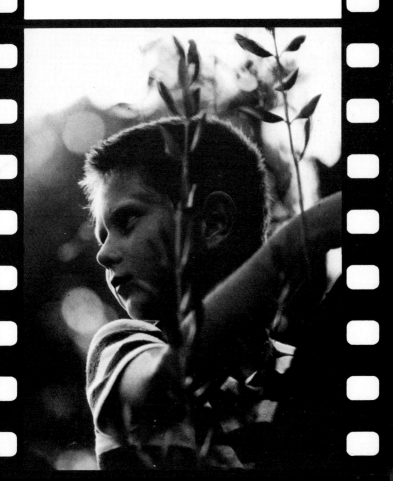

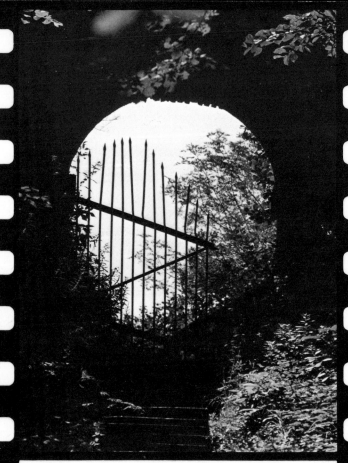

Tone down excessive contrast

23 Lateral and back-lighting, as we have seen, can produce interesting contrast effects. However, large areas of shadow can come out too dark. In these cases, we have to resort to some kind of fill-in lighting. With outside shots, you can use a sheet of white card, or metal foil. This can have a secondary effect: counteracting the blue colour which in summer — especially at midday — appears in the shadows. Exactly the same technique can be used in clear places — including the beach — where toning-down is needed, particularly when the subject is moving. Best of all, of course, is the use of fill-in flash (see **133**, below).

Black-and-white photos

In recent years, colour photography — either slides or prints — has become as widely used as black-and-white. However, and without denigrating the importance of colour, I disagree totally with the frequently repeated assertion that colour has completely displaced black-and-white. After all, colour painting did not replace drawing or etching! Both colour and black-and-white have a right to exist, and so we now give you some tips dedicated especially to the fans of black-and-white.

Standard sensitivity

In earlier times, 40 ASA was considered a standard speed, but nowadays black-and-white materials have improved so much that sensitivities two to four times higher may be taken as standard. Modern standard sensitivity lies between 50–200 ASA. We can take advantage of these higher speed films by operating at much faster exposure times.

Ruined gate photographed with back-lighting.

Generally, use rapid exposures

Black-and-white film has gained the reputation of having almost magical exposure properties and, indeed, it has. However, the greater sharpness of the image and the grain effect resulting from rapid exposure must also depend on the subject. Fast exposure times require uniform and even illumination. When the theme has strong contrasts (filtered light, or back-lighting), an increase in exposure accompanied by a decrease in development time will help cut the contrast. (These points apply only to negative film, and not to black-and-white transparencies, which also exist.)

Sharpness and type of film

26

Less sensitive films tend to produce sharper photos, because the grain of 'fast' film is considerably coarser. The more sensitive films, of around 800 ASA, however, have been improved to the extent that small negatives can be enlarged to about 30×40cm. With postcard-size photographs, only an expert could tell whether the film had been fast or not. (In certain cases, the sensitivity of colour film also affects the sharpness of the image but not to the extent of black-and-white film.)

Themes for film sensitivities

27

High-sensitivity film does not have, as a result of the above, the resolving power and the fine grain of less sensitive film. No one would consider photographing a fine marble statue with a fast film. In theatrical photos, for example, I think it is better, if you want to record the detail of an exotic costume or the expression on an actor's face, to use flash and a slower film. On the other hand, fast film can be extremely effective in capturing impressions, and of producing a distinctly atmospheric effect.

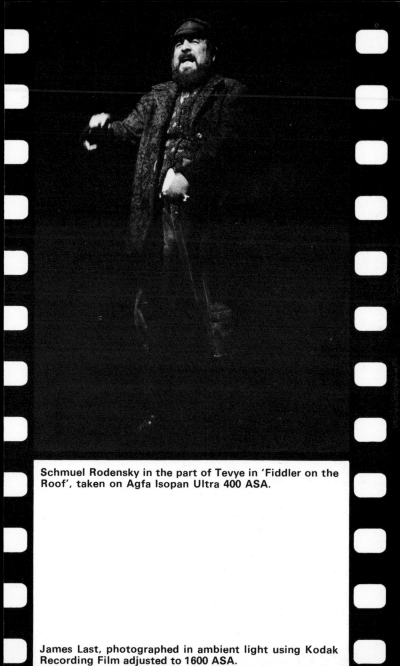

Schmuel Rodensky in the part of Tevye in 'Fiddler on the Roof', taken on Agfa Isopan Ultra 400 ASA.

James Last, photographed in ambient light using Kodak Recording Film adjusted to 1600 ASA.

Hard and soft films

The reproduction of contrast depends not only on the lighting, but also on the emulsion. So-called 'soft' films, of high sensitivity, handle a high degree of contrast quite easily. They give good results, for example, in night shots taken with back-lighting. On the other hand, low-sensitivity materials are 'hard', and give the best results in cases of poor lighting contrast. Films of the same sensitivity but of different makes can be noticeably different. Again, all films are affected by processing.

Make big enlargements for best results

Enlarge your black-and-white photos as much as possible. A postcard-size photograph (10×14cm) is much more effective than a 6×9cm snap. But no photograph will be shown to its best advantage unless it is enlarged to at least 18×24cm. If you don't have your own darkroom, try — just as a test — having a really big enlargement made of any of your favourite photos.

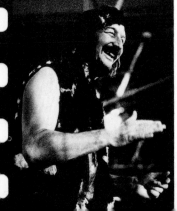

Enlargement emphasizes the features of the photograph (Study of James Last)

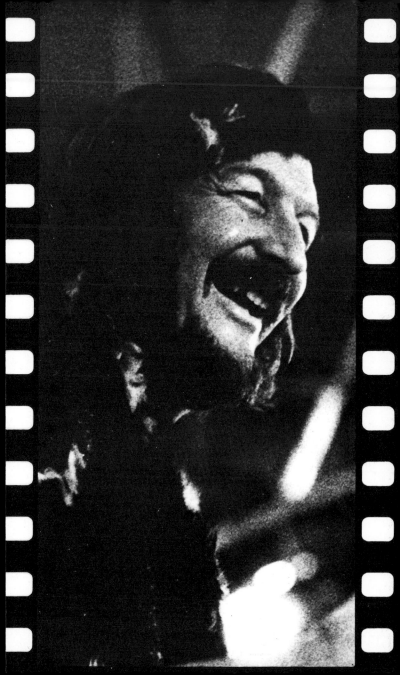

Colour photos

Colour is often a question of taste and, where taste is concerned, there are no experts. For this reason, many of the tips given in this section, particularly those concerning colour composition, have to be regarded not so much as firm rules but as pointers. However, I would always recommend that you go easy on strong colours, especially if your experience in colour work is limited.

Prints or slides?

The choice between slide and print is not irreversible. These days, you can make positive slides from colour negatives, and prints from colour slides. It is true, however, that slides and prints made in this way lose something of the original brilliance and contrast. The choice between slides and prints therefore really comes down to one consideration: if you want to make only first-class colour enlargements, choose colour negative film; if not, you'll be better off with reversal film.

Exposure for slides

When you use black-and-white or colour negative film, point the light meter at the darkest parts of the subject. With colour reversal film, the opposite is true: the light meter should be pointed at the lightest parts of the subject to get the greatest accuracy of exposure. Inevitably, therefore. with contrasting subjects you will find that colour reversal film requires a shorter exposure — and is therefore a little more sensitive — than colour negative film of the same ASA rating. With low contrast illumination, of course, the opposite is the case.

Colour and contrast

When colour photography first came out, one was usually recommended to tackle high-contrast subjects. In fact, colour film is very good for frontal illumination (which I don't think much of), and for cloudy conditions or indirect lighting. These days, however, we also rely on it for high contrasts. Nevertheless, in the most extreme cases of contrast, colour film still cannot match black-and-white.

There is one way out in cases of very high contrast. Irrespective of whether you're using negative or reversal film, you can set your aperture on the lightest parts of the scene and select a fast shutter speed; then the darker parts of the picture – people, trees, bushes, etc – will appear in silhouette.

Variation of colour with height of sun

In the early morning and late evening, light has warm colours (reds and yellows) in it. On clear summer days, however, the colour of the light is much colder (bluer), especially towards midday. And, while there are usually no complaints about warm lighting, colder lighting tends to produce a disagreeable effect. In cases like this you need a clear pink filter (R 1.5 filter or Skylight filter). The colours can also be improved with flash. If background scenery is strongly illuminated with reds or blues, and people near the camera are lit with flash, you can at times get some extremely interesting colour effects. Again, you should try out colour effects for yourself by photographing a given subject – say a scene or a monument – at various times of day from exactly the same position.

When the sun is high, the colour temperature is also high. As the sun goes down, so does the colour temperature.

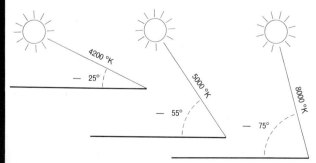

Getting rid of blue shadows

34

With colour reversal film, a blue effect is usually produced in photos of scenery when the sun is high, or in shaded subjects. A blue shading can also occur when there is a covering of cloud, particularly if it is thin. In such cases, colour negative film is better than reversal film, in that it very largely eliminates this problem of blue shadows. (On the other hand, it is also true that poor processing of negative film can give this blue effect to prints!)

If you use reversal film, you can avoid blue shadows by including in the main plane of the photograph a red, orange or yellow object. If you're photographing mountain scenery, for example, a camp-fire in the foreground will offset the coldness of the background tones.

Green reflections

35

Light reflected onto coloured surfaces can catch the eye and give a disagreeable effect. Green fields or green-painted walls can reflect green light onto the subject. Photographs of people near low trees are going to run into this sort of problem, with reflections coming from green leaves on one side, and green grass on the other. In such cases, if you cannot offset these reflections with flash, it is better to forget the photograph altogether.

A very different effect comes from sandy surfaces illuminated by the sun: they reflect light perfectly. They disperse those ugly shadows and wash the main subject with lovely warm tones. This warmth is even more enhanced if the cause of it appears in the picture.

Coloured needn't mean garish

36

You're much more likely to be able to describe an oil painting as garish than, say, an engraving. In photographs, too, an excess of colour produces an unpleasant, tasteless and confusing effect, particularly when the colours themselves are very bright. If you're not confident about a colour theme, get the camera as close up to it as you can. The many small and varying colour elements will then blend into a single coloured surface which permeates the whole picture and from this multitude of colours you can select only a few.

Chromatic perspective

As we know, green and blue are cold colours, while red, orange and yellow are warm. These last three have a magical attraction for the eye. A girl dressed in orange, for example, set against a blue sky really stands out against the background, looking almost as if she is moving out of the picture towards you (chromatic perspective). A blue object set against a red background, however, doesn't have nearly so sharp an effect.

I can't stress too highly this art of colour contrast. Many photographers place a girl dressed in red in a green setting or standing against a blue sky so as to obtain the famous 'red point' (focal point).

Watch the complementary colours

The opposite of black is white — that much is obvious! But every colour has its complement, too. The opposite of red is blue-green (or cyan), the opposite of deep blue, yellow, and of green, magenta. Two complementary colours in the same photograph, on large surfaces opposing one another, give a most strident contrast. Looking at such a photograph makes you cringe. This doesn't mean, of course, that it is not possible to arrange complementary colours tastefully in a photograph. If the colours are, for instance, refracted and therefore not particularly brilliant, there will be no problem in juxtaposing them. A reddish-brown boat reflected in the green waters of a lake can give a remarkable aesthetic effect.

The chromatic circle with complementary colours placed opposite each other.

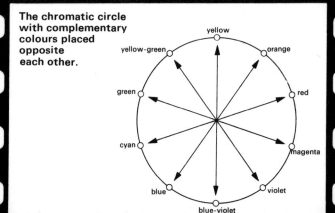

Tone on tone

Our principle of colour economy can even be taken to extremes. It is precisely those photographs which preserve an overall colour harmony that have the greatest attraction. You can even use the achromatic colours (black, white or grey). The surface of snow or the skin of a donkey reflect distinct tones — which normally we don't notice, but which show up clearly on a photograph. Of all my colour photographs, my personal favourite is one of a little white-painted chapel on the Greek island of Pharos, taken against a backdrop of white clouds, and it is the white which makes the picture.

The texture of the sky is different, of course, from that of a similar photo taken in black-and-white. To see what I mean, try taking some comparative photographs of an apparently colourless subject, using colour and monochrome.

Colour depends on illumination

The angle of incidence of sunlight has a marked effect on the colour of a subject. If you want to take a photograph of a little girl wearing a green skirt and a red jersey set against a blue sky, and you don't want your colour sense to scream with pain. try taking it in side-lighting. The dark shadows on the clothing will tend to reduce the harsh contrasts. With back-lighting, the sky would appear completely white while, with frontal lighting, the great green area of the skirt could form a border around the redness of the jersey. As you can see, too-vivid colours can be decisively modified. The simplest thing is to move around your model, and see which is the best light to take it in.

Films for daylight and artificial light

As you may know, there are two types of colour film on the market, one balanced for daylight and the other for artificial light (negative films carrying the mark 'universal' can be used for either type of lighting without a filter). In general, for daylight, or with blue flashbulbs or electronic flash, daylight-balanced film must be used, the other type of film being used with tungsten bulbs. For photos of night-lit streets, either type of film may be used. For myself, I like the blue effects in lighting, and prefer artificial-light-balanced film; the majority of films of this type have quite a high sensitivity and can therefore be used for night photographs without difficulty.

Using artificial-light film in daylight

Used in daylight, film balanced for artificial light can produce a marvellous unreal blue. If you want to try this, however, make sure that you don't get a blue haze over the whole picture by doing one or more of the following:

1. Include a strong red somewhere in the photo. Intense red is complementary to blue in artificial-light film.
2. Try to get some black parts in the picture (silhouettes, back-lighting effects, etc).
3. Use fill-in flash with a warm-coloured filter (converter filter R12, 85, 85B or an orange filter).

With the diaphragm wide open, and using a telephoto lens, you can produce an extremely small depth of field. By moving the point of focus, you can obtain completely different effects. In the photos above, the sharpest focus is in the main plane of the picture (left), and in the background (right).

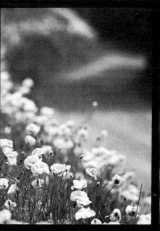 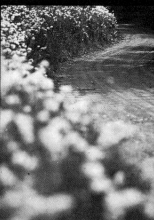

Sharp colours and shapes

With the diaphragm wide open, you can pinpoint the main motive in sharp focus whether you're using black-and-white or colour film. Usually, you tend to think of things in the main plane as requiring the sharpest focus, but there are many interesting photos — I myself have a collection of them — where the focus is in the background. The blurred forms in the foreground cover parts of the background image, emphasizing its sharpness.

Infra-red colour film

This type of film produces some amazing colour transformations:

1. The green of living matter becomes red.
2. The green of a painted surface becomes blue.
3. Yellow becomes white and white yellow.
4. Red becomes yellow.
5. Blue becomes black or red.

This type of film should be loaded and unloaded in a darkroom, and always used with a yellow or clear orange filter. Avoid exposure slower than 1/30sec. With a yellow or orange filter, sensitivity can be adjusted to about 80 ASA. If you want to use this effect for an important subject, take three photos, one at the normal aperture, and the other two at one stop either side of it.

Colour plates on first centre page

Top right: **This photo was taken with infra-red; the contrast of colours with normal film** (top left) **is clearly visible.**

Bottom: **A scene on the island of Rhodes, taken with a variously coloured multiple-image adaptor.**

Multiple-image adaptors

Multiple-image adaptors (prismatic lenses fitted in front of the camera lens to give multiple images) can be fitted to obtain special effects. I suggest that they should be used mainly for highly contrasting subjects. You can also get adaptors with different-coloured facets, and there are filters with coloured sections, which can be fixed on to the prismatic lens.

These new accessories and various combinations of them can transform pallid or high-contrast scenes into fantastic colour compositions. For best results, a reflex camera should be used, as the effect can be observed.

Photographs with coloured lights

The colour of a flash can be changed at will simply by covering it with coloured cellophane. Another useful source of coloured light is the Comptalux range of coloured spotlights made by Philips, available in red, yellow, green and blue.

If you want to try your hand at composition with coloured lights, begin with reflective subjects. Try not to include large areas of self-colour: rather the reverse, try to include a lot of neutral black or white. You can use either daylight or artificial-light film for this type of photo, although personally I prefer the latter.

Colour plates on second centre page

Top: James Last. Black-and-white enlargement reproduced with a triple-image prismatic lens and a colour filter on colour negative film.

Centre left: A stack of tubular steel chairs, illuminated with yellow and blue light.

Centre right: Silver mask illuminated with different colours, with part of a Comptalux spot coming into the picture.
Bottom left: Old-fashioned sewing-machine throwing black and coloured shadows by means of a sheet of crumpled cellophane.

Bottom right: Colour composition using a Philips Comptalux spot, taken on Agfachrome artificial-light film.

Colouring black-and-white photos

Black-and-white photos can be transformed into colour compositions using coloured multiple-image adaptors. With these, it is only necessary to photograph an enlargement of the black-and-white photo (13×18cm or, even better, 18×24), using colour negative film, with a coloured multiple-image adaptor fitted in front of the lens of your camera. If you can use a telephoto lens, and have the coloured multiple-image adaptor somewhat separated, you can obtain some especially colourful effects.

Filters

The majority of filters have brilliant colours — yellow, orange, red, green, blue. These, however, are exclusively for use with black-and-white film. With colour reversal film, the only suitable filters are ultra-violet, pink (also called Skylight or R1.5), and a polarizing filter. At times a bluish filter can be useful and also, notably, a converter, which is salmon-coloured. With colour negative film, it is usually only necessary to use a polarizing filter, mainly to protect the lens from ultra-violet.

Filters for grey tones

In black-and-white photography, colours are transformed into various tones of grey. However, the film does not always reproduce these colours in the way the human eye would expect. For instance, blues which look quite dark to the eye come out light grey, and blue sky often looks white. This effect can be improved with a yellow filter.

To understand the effect of filters in black-and-white photography, it is only necessary to remember this: parts of the subject that have the same colour as the filter come out lighter, while those of its complementary colour come out darker, or even black. The majority of filters require an increase of exposure time, given by the 'filter-factor' which is usually indicated on the edge of the filter, or in the accompanying leaflet.

Filters for 'cleaning-up' photographs

Filters are used not only for reproducing colours, but also for cleaning things up, and sometimes for making them disappear! Rust marks on a document, for example, can be eliminated by using a red or orange filter. In this case, the letters must be written in a black or blue ink since, naturally, red would disappear completely from the photo. Obviously, therefore, a text written in red would need a blue filter. Likewise, freckles on a girl's face — or any other reddish mark on the skin — can be toned down with a bright red or orange filter. There is, however, a snag with this: it has a tendency to spoil the colour of the lips. If this happens, there is still a way out: get your model to use a blue or violet lipstick!

Filters for piercing haze

Short wave-length radiation, such as blue, violet and ultra-violet, is reflected to a great extent by atmospheric haze. Longer wavelengths, such as those in the yellow, orange and red bands, get through atmospheric disturbance such as haze rather more easily. You can see, then, that an orange or red filter can help you photograph through haze. A distant haze can be clarified with a UV or Skylight filter. For mountain mists, because of the more complex vista, use a UV filter. This filter (which is colourless) can be left permanently fitted to the lens of your camera, except when you want to take shots in back-lighting.

Dramatic black-and-white effects with orange and red filters

Warm-coloured filters reproduce blue sky in a dark tone, and thus give good contrast to white clouds. Yellows look grey, oranges dark grey, and reds black.

At the same time, these filters reduce the blue light from the sky falling on the shadows, which therefore appear darker. In this way, photos have a higher contrast, which is always to the good in cloudy shots of landscape or frontally lit façades.

Personally, I use orange or red filters as often as I can. For my taste, yellow or light orange filters have too weak an effect on black-and-white material.

How and when to use a green filter

With black-and-white film, orange and red filters, as well as those in the yellow range, have the unfortunate effect of bringing out flesh tones too light. They remove freckles, it is true, but at the same time they lighten the bronze tones of the skin. Therefore, they should not be used for close-up portraits. Green filters (not yellow-green) suit these tones, and also reproduce the sky in quite a dark tone. I use them preferentially for beach photographs, or for studies of figures against bold scenery.

Filters for colour photography

Apart from UV and polarizing filters, which are colourless, the filters used in black-and-white photography are not suitable for colour photography. They can in some cases, however, be used to correct the colour of the light. For example, a Skylight filter (R1.5) can adjust the blueness of shadows which appears in summer around midday. Again, a reddish conversion filter makes it possible to use film balanced for artificial light in daylight, and a bluish filter allows you to do the opposite.

Colour effects

You can get some superb unreal colour effects by using colour filters out of their normal context. For example, a red sunset very much 'larger than life' can be obtained by using a red filter which would otherwise be used for black-and-white work. Again, orange, red, yellow or green filters should be used only with colour reversal film to obtain impressive slides of silhouette or back-lit subjects.

Reflections disappear with polarizing filters

Polarizing filters are really marvellous; in general, they are used to darken a sky with colour film or reduce reflections. There is one case, however, where I prefer not to use them: I'm referring to their ability to reduce totally reflected light from windows and other bright surfaces, which could eliminate a desirable effect. I want to make it clear that it is impossible to make reflections disappear in a straight frontal shot. It is when the camera is at an angle to the subject that reflections disappear. It should also be noted that the polarizing filter reduces or removes reflections only from non-metallic objects, such as water, enamel, porcelain and so forth.

Landscape with polarizing filters

Colour photographs of landscapes taken with a polarizing filter usually have much greater contrast and much purer colours than the eye sees without a filter. The sky is much bluer, and the clouds stand out against it. Any haze there might be disappears. The green of lawns and trees, the red of brick or tiles, and all other colours are reproduced more vividly. Shadows don't show up as blue; in fact they acquire a really deep black tone. All these effects depend on the rotation of the filter relative to the camera lens. This can be checked quite easily by looking through the filter or camera screen and rotating the filter until the best effect is obtained. The position of the sun also has an important part in the increased contrast effects, which are most noticeable in lateral lighting.

'Underwater photography' with a polarizing filter

Because a polarizing filter can pierce the surface reflections of water, it is possible to take photographs of fish and aquatic plant life that would be very difficult or even impossible to take otherwise. To do this, you have to take your photograph with the camera at an angle of about 55° to the water surface. Make sure that there are no images reflected on the surface of the water — change your position if necessary; they can greatly disturb the stretch of luminous surface facing the camera lens. For this reason, on cloudy days, painted surfaces such as those on boats and cars, as well as the surfaces of lakes and pools, can have a milky effect. In these cases, a polarizing filter is indicated.

'Day-is-night' effects

Usually the iris is opened about one-and-a-half stops above normal when using a polarizing filter. If, with a blue sky, you take a photo of scenery without making this correction — or even with the iris stopped down slightly — the intense blue is changed to a sky of 'Neopolitan' black, so as to create an effect of artificial night, as if the scene were lit by moonlight.

And one last observation on the use of polarizing filters: beware of using them with wide-angle lenses. The effects become exaggerated as the focal length becomes wider. In most cases, however, the normal lens of your camera will be suitable.

Portraits

Portraits can be disappointing when they are taken from too far away. Whatever you do, try not to make your models come out as little dots in the middle of a vast landscape! Get as close to the subject as you can. Take risks to take portraits! The portrait can present difficulties, but its bad reputation is without real foundation. I'm doing my bit to dispel the difficulties with the following tips. I hope you find them useful.

Lenses and distances

To preserve the right proportions of a handsome face, it is not advisable to get closer than about 1.5m. If you're using a standard lens, the head will not occupy the whole field of vision, and you will have to be content with a head-and-shoulders shot with, perhaps, an enlargement later. But if you happen to have a tele-photo lens, the head will fill the frame at 1.5m. With a small format, ideal focal lengths vary between 90 and 135mm. With 6×6 the focal lengths are from 135 to 160mm, and there is nothing to prevent your using longer focal lengths, if you wish.

Optimum distances

If by any chance you have to take a portrait from closer than 1.5m with only a standard lens, and you reach the point where the head completely fills the picture, there is still a solution: take the photo in profile. The head of a child can be photographed from the front at a distance of less than 1m, or in full or half profile. In these two cases especially you don't have to worry about the distorting effects of perspective. In cases of doubt, it is always better to choose a shorter distance, but I must still stress that, with a standard lens, it is better not to get any closer than about two metres.

Outside portraits

61

Deep dark shadows are the worst enemies of portraiture, and can make a face unrecognizable. The best way to prevent this effect is to use a light-coloured surface to reflect the sun; a white sheet of cloth or cardboard does this very well. On the beach, the white or golden colour of the sand will fill in the shadows. The most radical and most effective method, however, is to use fill-in flash. You can also take very good portraits in cloudy conditions. The white, diffused light gives an illumination without shadows. So I repeat that the best outside portraits are taken when there is no sun.

The 'best side' of a face

62

Some women hate their passport photos. In some countries these must be taken with the left ear presented directly to the camera. These ladies know it would be much better if they were allowed to present their right side to the camera. Some look more attractive from the front, others in profile. If you look closely at your models, this will be obvious. If one has a prominent chin, it will be better if you can get the camera into a rather high position; likewise, a large forehead will look better if you take it from below.

At times I've known a girl to be dissatisfied with a magnificent portrait. This can only be because she is used to seeing herself in a mirror, and experience has shown me that such girls are pleased only with a 'mirror-image' portrait: that is, an enlargement made with the image reversed.

'Watch the birdie'

63

Your model need not necessarily look at the camera but, at the same time, it is an exaggeration to say that he or she should never look at the camera. This is justified only in group photos — certainly not in portraits. My own preference is for photos in which the model looks at the camera. They have more impact; they make you feel more involved.

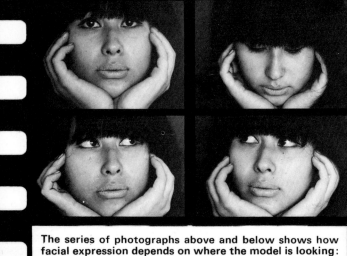

The series of photographs above and below shows how facial expression depends on where the model is looking: towards the camera, up, down, left or right. All the photos were taken with direct frontal illumination using a halogen lamp.

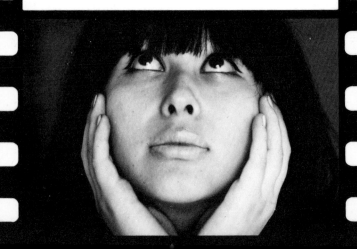

Position of the head

It seems to be quite the thing nowadays to take straight frontal portraits. The eyes, the face and the body lie in a dead straight line with the camera. Yet it cannot be denied that a model whose head is turned a little looks a lot more natural. *A face directed straight towards the camera gives the illusion that the body is a little to one side*. Portraits in which the face, the eyes and the body face in different directions give a much more natural impression.

Focus on the eyes

With the iris wide open, or with a lens of large focal length, the depth of field is very short. Fortunately, in a portrait, it is only necessary to get the eyes really sharp. There is slight tolerance on the sharpness needed in, say, the tip of the nose, or the ears. The pupils are easily definable points and are very often used to set the focus of the portrait lens. In a three-quarter view, focus on the eye nearest the camera.

Lighting for portraits

A flash or a spotlamp are sufficient for a portrait. Often, you don't need to lighten the shadows, for example if you direct the light towards the ceiling, or use direct frontal lighting, or if you're looking for special lighting effects. In most cases, however, I suggest you use direct lighting. The lamp can be reflected from a white card towards the model, softening the shadows. But I would stress that if you aren't sure where to direct the lighting, point it towards the ceiling. Eight times out of ten, you'll be well satisfied with the result.

Effects of illumination

One of the most valuable characteristics of photography is that it helps us observe things. This is true of photography in general, and especially of portraits. We must absorb not only the appearance but also the soul of our model. For this reason, we must take all the time needed to determine the position of the camera, the set of the head and, most of all, the illumination. A typical masculine head would receive light from the side and, to a certain extent, from the front. This ensures that the 'topography' of the face can be well rendered. On the other hand, a middle-aged woman is better photographed in a softer illumination. Finally, a strong profile can be made in the form of a silhouette against a luminous background, with or without illumination on the profile itself.

Portraits with more than one spotlight

Don't try to take portraits with more than one spotlight until you have enough experience of using a single light.

In general, there should always be one main spotlight. The other sources of illumination can be applied as subsidiaries to produce an overall lightening of the shadow areas.

If we have a model in dark clothing, and also a dark background, we can use one spot as a back-light. With this, we can make the subject stand out by means of rim lighting, setting off the subject against the background.

Indirect frontal lighting: ideal for portraits

Diffused frontal lighting can be obtained by using a large white surface located behind the camera and illuminated with every available light. The reflected white light then falls evenly on the model. A similar effect can be obtained by placing a large sheet of translucent paper between the lights and the model. This set-up should be placed as close behind the camera as possible. This kind of illumination will produce fewer shadows than light reflected from the ceiling, and the photograph will not show any wrinkles or other blemishes. The only disadvantage is that faces do tend to look a little flat.

Portraits using flash

70

Flash has the advantage of catching spontaneous expressions. The subject doesn't have to keep still. As there are no continuous bright lights the model's eyes will be more comfortable, and the pupils appear wider. Lighting angles are the same as for spotlights or floodlamps; 45° to one side and 45° above gives good modelling, and a white card or sheet on the shadow side can act as a reflector so that shadows will not be too dark.

Watch out for the 'portrait face'

71

When you're taking a portrait of someone, you will nearly always find that they put on a 'portrait face' for the occasion. Sometimes it's due to the glare of the lights, or some similar reason. In other cases, the model puts up subconscious barriers against the camera's 'theft of the soul'. The experience of being photographed often produces a sensation of tension which is a mixture of fear and of feeling flattered. Therefore, one of the main things that you, the photographer, must be able to do is to get your model to relax. Keep up a conversation on things of mutual interest. Get your model to co-operate in setting the position of head and hands. Again, the technique of surprise often produces good results, the idea being to take the photograph at the very moment when your model is least expecting it.

Background is important, too!

72

One often hears it said that a girl in a dark dress should be set against a light background in order to obtain a good contrast. And, while we are to some extent entering the realm of personal taste here, I think it will be generally agreed that, in a portrait, the most important element is the face, with the hands at times also having a role. If then, we take as an example a girl with black hair and a dark dress placed against a black backdrop, we can see that the face and hands will stand out strikingly. Again, a redhead can acquire a beautiful golden colour when dressed in a light-coloured material and set against a light-coloured background.

Groups

In general, group photographs shouldn't be perfectly geometrical in their composition. If you think about class photographs taken during your schooldays for a moment, you'll soon realize that their appeal is more sentimental than aesthetic. However, with a little artistry, photos of small groups — of about three to six people, say — can produce some very nice results. Some examples are given below.

The group as a 'casual snap'

73

When you are taking a photograph of a group, there will of course be some arrangement. Nevertheless, this arrangement should not be noticeable. Try as far as possible, to set things up exactly the opposite to what you would do for a portrait, in that none of the models looks at the camera. The photograph should give the impression of a casual snapshot.

Groups with principals

74

In some groups, there are people who play principal roles. I am thinking of, for example, a pair of newly-weds surrounded by friends and well-wishers. Here, you should try to get the rest of the group to look at the young couple, while they — and only they — look at the camera. In this way, they will stand out against the rest of the group.

Keep them occupied

75

Photos of groups in which everyone has something to do give especially natural results. So you should try if possible to keep your models occupied. Photos in which people are playing with a ball, swimming, playing cards, or something like this, are much more interesting than those in which – as happens fairly frequently – there appear a few separate figures lost in a vast expanse of photograph.

If you decide to take an action photograph like this, you should bear in mind that people who are concentrating on what they are doing don't have time to look at the camera. You can of course use the element of surprise, but it is true that people who are busy don't look at the camera anything like as much as those who, knowing they are being photographed, put on their 'Sunday faces'.

Groups in a landscape

76

Suppose you are going to take a group near the sea, or among mountains, or indeed in any open-air setting. Your subjects, of course, have the chance to let their gaze wander quite naturally over the scenery in the distance. You should not, however, try to take the whole of the space which separates your group from the background with equal sharpness. When you are taking a photograph like this, therefore, you have to decide which is the most important to you, the scenery or the group. You will probably decide that the group is what you want, and that the scenery is only a backdrop. Thus, you should focus sharply on the group and let the background appear slightly blurred.

Illumination of group photographs

77

With the exception of special illumination effects such as back-lighting, groups usually come out best with oblique frontal lighting. This is equally true whether you are using natural light or flash. With interior shots, it is best to get the lighting as far away from the group as possible so as to obtain an overall reflected lighting effect. In the group photo more than in any other, hard shadows give an ugly result. Lights must be positioned so that there is no 'fall off' of illumination at one side.

Action photos

The best action photography has two prerequisites:

1. You must know your camera extremely well.
2. You must never try to economize on material.

For obvious reasons, action photos fail more often than, say, landscapes. Therefore, and to avoid disappointment, it is best to take at least two or three shots of each subject.

Speed is not magic

78

Action shots require a certain capacity for quick reaction, but this only comes with knowing your camera well enough to operate it without much thought. Practice with the camera will give you the necessary dexterity. Work till you are tired of estimating distances, at positioning the camera, and at the differing requirements of horizontal or vertical shots. But never forget that there is always a risk with action shots.

Have your camera ready

79

Automatic cameras aren't the only ones that allow rapid action. Even if your camera doesn't have a built-in exposure meter, you can still get it ready in advance. Certainly, aperture and speed can be set in advance (see Section **14**), and, if you can keep the lens fairly well stopped down, you can even set your camera to fixed focus. While this effectively converts it to a box camera, it is best if you want to take action shots. At f/8 with the lens focused at 5m, you will get a sharp image anywhere between 2.5m and Infinity while, at f/11 and 2m, the area in focus comes down to about 1.5 to 3m.

More about focusing

Precise focusing is the most difficult problem with action shots. This becomes even more difficult if you have to operate with the iris wide open. which you often have to do either because you want the subject to stand out against the background, or simply because the light is bad. If the subject is coming towards you, you won't be able to set the distance exactly anyway. It's better in this case to pre-focus on a particular point and wait until the subject arrives there. Then, shoot quickly.

Objects which are not moving too quickly can be treated differently. Here you can select a given distance – 2 or 3m, for example – and move up until you yourself reach the point.

High-sensitivity films

Of all the aids to action photography, the most useful is high-speed film. For one thing, it allows you to take pictures in poor lighting conditions at relatively fast shutter speeds, and for another – no less important – it has a wide tolerance for various types of illumination, and gives good contrast. This is true. for example, in back-lit action shots; high-speed film can go a long way towards offsetting the inevitable errors which arise.

Action shots with flash

Flash photographs of action situations can give good results in the majority of cases where the flash and the camera are synchronized. The distance, say about 2.5m, and the corresponding aperture can be set in advance in just about every case. However, you will realize that the frontal illumination given by flash may not always give as pleasant a result as you would wish. One way out of this is to hold the flash in one hand and the camera in the other. In this way, at a distance of 2 to 2.5m, you will get the effect of lateral illumination. Of course, this method can be used only in situations which do not call for extremely rapid action.

Action shots with two flashes

Most outside shots at night (for example, photographs of sporting activities or in the theatre) do not occur in places provided with suitable reflective surfaces. Any photo taken in these conditions, therefore, with only one source of illumination, will end up with far too much contrast. Here, the solution is to use two flashes: one separated from the camera in the way described above, and the other fixed to the camera in the normal way. The extension flash can be at a distance and fired by means of a slave unit, sometimes called an electric eye. It will fire at the same time as the flash on the camera.

Bounce-flash effects for action shots

Directing the flash towards the ceiling gives all-over, soft reflected light across the whole room. This means that someone only 1m from the camera will have the same exposure as those 2 or 3m away. Fit the flash to the back of a chair or a door by means of a camera clamp, and aim it at the middle of the ceiling. If you connect it to the camera by means of a 3–4m extension lead, obtainable at any dealers, you can then move around the room and photograph your subjects at will. The method is particularly useful at parties (but watch that lead!) or for natural shots of children. There are more hints on illumination in paragraph **140**.

Catch them by surprise

By their nature, action shots are unprepared at the instant you reach for the release. In paragraphs **127** and **128**, you will be told how different types of lens can help you overcome this. But there is one thing you must know about distance setting: practice makes perfect. Learn to calculate by eye. At the same time, don't measure up the main motive, thereby alarming your models. I prefer to measure the distance to an object which I guess to be the same distance from me as my 'victim' is, but in a different direction. Only when everything is absolutely ready do I suddenly swing round and fire the shutter, before anyone realizes what is happening.

An action shot with a really natural effect, despite having been prepared in advance – or perhaps because of it!

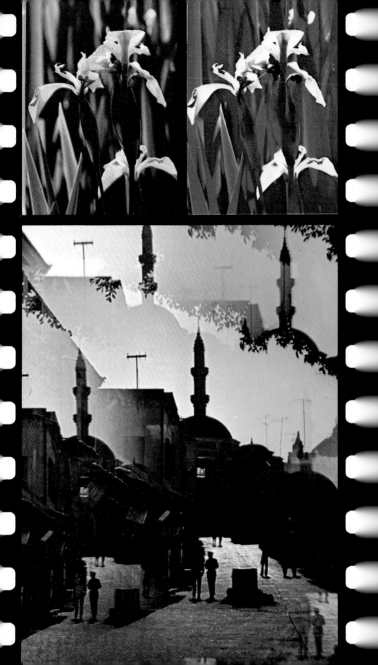

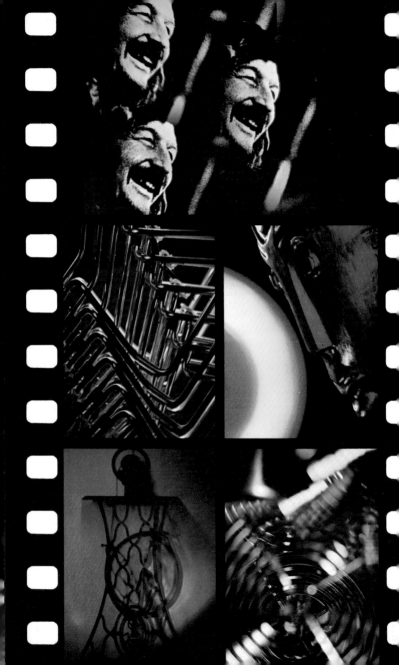

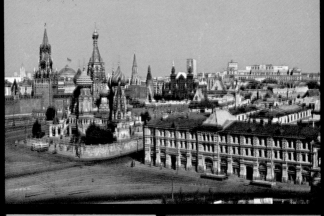
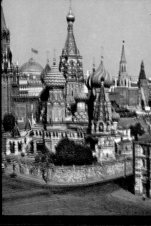

The 'posed' action shot

A posed action shot is, of course, a contradiction in terms. On the other hand, it is not really possible to take a photograph utterly without preparation. Often, however — and particularly in the theatre and ballet — a photograph is reconstructed after the event. The photographer sees the production first, and notes the most photogenic scenes. Then, afterwards, the actors repeat these scenes for the camera. Again, at press conferences, politicians are asked to repeat their best-known gestures or other mannerisms so that photographers can record them for posterity. So, if this sort of thing is good enough for them, it should be good enough for us to copy with scenes which interest us.

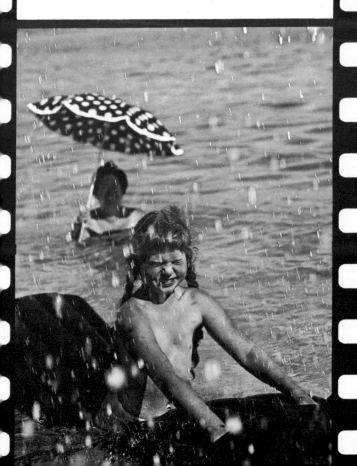

Scenic photos

Scenic shots can be taken in either town or country settings, and there is little difference between them from the point of view of composition.

The majority of these subjects will be characterized by impressive spatial effects, effects which are intrinsic to the nature of the place. Many of the tips given in this section are aimed at helping you to get this spatial effect into your pictures.

Some preliminary remarks

Scenes like the Alps, the Mediterranean coast, or the Scandinavian fjords are almost obligatory for the camera. Yet it's funny how many people avoid taking scenic photographs, just because their first attempt met with failure. This may simply have been because they tried to reproduce a panoramic vista in too great detail. In this type of shot, you've got to isolate the main feature which catches your attention. Again, wherever possible, you should try to get something fairly solid into the foreground of your photograph — a rock, a tree. the stern of a boat, a fence, something like that. And, of course, people can at times make a perfect foreground to scenery.

Again, get close up

In general, I have always found that it is better to go for a particular detail of a scene than a panoramic view. From a long way away, everything looks alike, but as you get closer, the intrinsic character of the subject begins to show up. The sort of scenery to get close up to in the city might be, for example, long alleyways, or gardens of flowers, or views of doorways and columns; in the countryside, it will be groups of trees, fields, tracks, or lakes in which greenery is reflected, or at the seaside, rocky coastlines.

Black-and-white shots using filters

One of the best filters for scenery is green and, oddly enough, one of the least well-known. Yet it brings out the green of vegetation beautifully, and gives positively ethereal effects with some trees. At the same time, it darkens the sky, exactly as would a dark yellow filter. Again, with monuments and other architectural shots, orange and red filters are a great help. They lighten the tint of stones, and make the clouds stand out against the sky, while at the same time increasing contrast. They are particularly good for frontages illuminated from the side.

Lateral illumination

Light coming from the side of an object can greatly help in outlining its form. In some cases, lateral illumination can produce a texture that you can almost touch. Think, for example, of the ripples left in sand by the receding tide, or the relief on the façade of a building. Frontal illumination here would give no sense of depth. Mind you, it is not at all easy to say what is the best illumination for the façade of a building, but waiting for different effects is worth the effort.

Back-lighting can produce a great effect of depth, especially when the subject is far enough away for it to throw a deep shadow on the ground pointing towards the camera.

Walls should be vertical

If by any chance you want to get a result that looks like the Leaning Tower of Pisa, then by all means hold your camera askew. In some cases, however — often because the effect is too small to notice in the view-finder — walls will come out crooked in the picture. If this is only a small tilt, it can easily be corrected later, when you make the print. But, if the camera has been allowed to point upwards, even if only a little bit, the effect is more difficult to correct. In cases where the subject is too high to get in your view-finder, and you don't want to risk tilting the camera, you'll have to take a few paces backwards. Another solution is to find some way of raising your viewpoint: a ladder, a wall, or something like that. Switching to a wide-angle lens can also help.

If you have to tilt, tilt in a big way

If you have to point the camera upwards, make a job of it! The walls of a tower photographed a little out of true will give an unattractive result, but when they are taken from a really odd angle they can acquire a fantastic new dimension. A baroque façade or a television mast shot obliquely from below can look much more interesting than a conventional photograph.

Opposite page (left): **A church in Moscow. The elevated road in the foreground gives depth to the picture.** Right: **The same effect is obtained with the leaves and grass in the foreground.** Below: **The Parthenon of Athens taken from inside, pointing the camera upwards.**

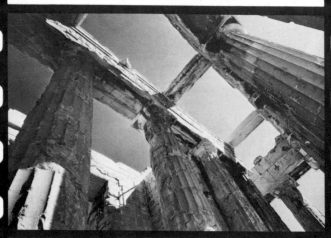

Watch the horizon, too

In mountain scenery, irregularities of the ground often block off the horizon. But in scenery which includes a wide expanse of water or of wide flat countryside, it is necessary to make sure that the horizon comes out level. If it comes out any other way, it can give a distinctly odd effect, and will call forth ribald remarks about making water flow uphill!

For good composition it is usually best to have the horizon line a little above or below the centre of the picture.

Pictorial emphasis

All the dark parts of a picture tend to look nearer, and the lighter parts farther away. This isn't only a kind of optical illusion. A dark border gives a sensation of being really closer than the light parts of the picture. You can take advantage of this effect by shooting through a dark doorway, through trees, or through a window. If you arrange a figure in silhouette within the frame of a doorway against a lighter background, the impression you obtain of depth is really tremendous.

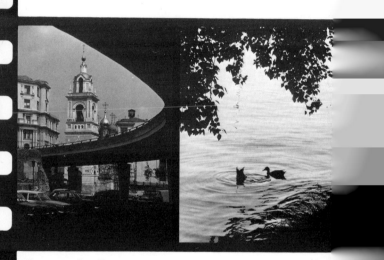

Perspective lines

The Italian Renaissance painters certainly knew how to create three-dimensional effects by the use of lines of perspective on a flat surface. The present-day photographer can also make use of lines which narrow towards the background, such as alleyways, railings, and similar things, using a small aperture for good depth of field and getting as close to the nearest part of the subject as possible. These lines of perspective can be directed towards the centre of the picture or, for example, to a point situated in the upper right quarter of the photograph. A diagonal extending from bottom left to top right attracts the eye into the interior of the photo. This is because we unconsciously scan pictures from left to right. If you want to photograph a river running towards you, for example, its course should go from left to right.

Focus in different planes

You quite often see photographs taken with the lens stopped down so far that the foreground ends up with the same sharpness as the background. Yet the sense of spaciousness is much greater if one extreme is sharper than the other. As I've already pointed out, this effect is obtained only if the diaphragm is open as far as possible. After all, the eye itself sees background as a blur when it focuses on an object; likewise, we can't focus sharply on nearby things when we're looking into the distance. So you shouldn't ignore the possibility of taking photos with the background sharper than the foreground, either.

A scene in Greece. Note how two totally different effects are obtained when the focus is transferred from the foreground to the background.

Night-time city scenes

Fast films, with a sensitivity of about 400–800 ASA, enable you to take photographs at night without having to use a tripod. Shop windows and city lights will provide sufficient illumination. The relatively fast exposure times will allow you to take action shots without a flash. You can also take colour photos at night (films from 80–800 ASA), but here you will need a really big lens (f/2, f/2.8). If, despite everything, the exposure time is going to be so slow as to endanger the picture, find some solid object on which to rest the camera.

Night-time photos in rain

You can get some fascinating effects by photographing rain-wet city streets, with reflections of shop windows and neon signs. If your camera is loaded with high-speed film, you won't need a tripod. To protect your camera, use an umbrella, and shield the lens with a lens-hood. Don't forget your filters, either. If you want to take colour photos, you can use film balanced for daylight or artificial light — it depends on your own taste. The colours produced by the former will appear warmer, and by the latter, colder. Photographs taken in twilight can be interesting, too; if you use artificial-light film, the dark sky takes on an unusual blue tone.

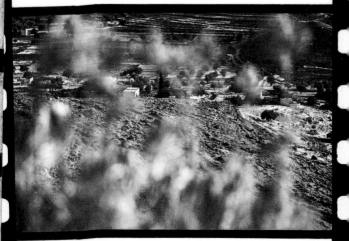

Some special effects

Some night photographs can be made most effective by the use of a fine piece of gauze in front of the lens. With this, luminous points look like little stars. With colour photos, you can get some interesting effects by shooting through a tube of coloured metal foil. To get the best out of these techniques, you should use a reflex camera. You can also get these effects with the so-called 'starburst' attachments. With these, the position of the stars varies as you rotate the attachment.

Holiday photos

If anyone asks when most photographs are taken, the answer has to be 'When on holiday, or when travelling'. And, indeed, isn't it the same with you? New scenes and sensations in mountains, by the sea or in a foreign country almost force you to reach for your camera. In the following section, I will be referring as much as anything to the preparations you should make before you leave, rather than to the subjects you might encounter on your way. These were largely covered by the tips on photographing scenery given in the last section, which I hope you will find useful here, too.

Check your equipment

100

Some weeks before you go away, pay a visit to your supplier, and discuss the accessories you think might be useful to you in the mountains or by the sea. Very often, he will make small points about your accessories, but it will be exactly these things that will play an important part in obtaining good photographs. In order not to be disappointed, it is better to buy all the film you need before you leave home and, of course, use only films that you know.

Use sensitive film abroad, too

101

Many keen photographers travelling to the south of Europe tend to take with them less-sensitive black-and-white film which tends to give very high contrast. Their decision is because it is well known that the very bright light of Italy, Portugal or Greece permits much shorter exposures, so that slower film can be used. In these countries, however, the contrasts are much higher, too. Think of a stretch of street, partly illuminated and partly in shadow, or of deep shadows on people's faces, and you will see that it is advisable to choose faster films (100–400 ASA) which, being softer, captures these excessive contrasts rather better. If slower films are used, they should be processed in a compensating developer, to reduce contrast. These developers include Definol, Acutol and Perceptol.

Don't forget your flash!

With these excessive contrasts, you can't afford to leave your flash behind. Both colour prints and colour slides can be improved if the heavy shadows are relieved with flash. Again, in Mediterranean countries, streets, squares and cafés are at their most lively just when it is beginning to get dark, and a little cooler. Fortunately, modern electronic flashes are so light in weight that they won't run you into excess baggage charges!

Always load your camera in shadow

Never open the back of your camera in the full glare of the sun. This is particularly true when you are travelling. When you commit such an offence, your photographs may be adorned with the streaks caused by light creeping around the edges of the film. If you do have to load a new film outside, try at least to get the shadow of your body across the camera.

Film problems are not insoluble

If your camera jams because the film has torn, or because it has come out of the cartridge, don't despair for the photographs you've already taken. Wait until it is completely dark and put the camera under a coat, open it, and feel to see if you can find the cause of the trouble. Roll up the film and get it back in the cartridge, making sure that you keep the film under the coat and in the dark all the time. In this way you can at least save those shots you've taken already, and at the same time get the camera ready for re-loading. If you use miniature format, you might find that when you try to move the used film with the wind-on lever, it only drags at the film. In general, this will be because the holes in the film haven't engaged properly with the teeth on the take-up spool.

Colour film and high temperatures

Colour films are very sensitive to heat, even before they have been exposed, and the effect worsens the greater the interval before they are developed. If they are well insulated — wrapped up in clothing, for example — it is possible to protect them against heat. However, you should never leave your camera in the glove compartment of a car, even for a short time, because of the extreme heat that can be generated there. Exposed film should be unloaded as soon after exposure as possible. In the case of colour reversal film, try not to leave it more than four weeks between exposure and processing. It is preferable to have an even shorter interval; otherwise the colour reproduction and brilliance may be adversely affected.

Danger on the beach!

Any camera can be damaged by sand and salt spray. The beach is therefore a particularly dangerous area as far as your camera is concerned. There is, however, a good remedy — a plastic bag. Pack all your equipment in one whenever you go to the beach. Cameras are lubricated with oil in special workshops; the oils of the beach, however, don't do them any good at all!

Travelling abroad with photographic equipment

In the majority of European countries, the tourist can travel for a limited period with his photographic equipment without difficulty. However, before you go, it is advisable to check with the consulate of the country you propose to visit as to the regulations concerning the temporary import of photographic apparatus. There are sometimes limits to the number of cameras or the amount of unexposed film you may bring into the country. If, after crossing a frontier, you are unfortunate enough to lose a camera that you have declared on entry, you should lose no time in reporting it to the police, because, in addition to the loss you have already suffered, you may also have the extra misfortune of having to pay import duty.

Can I take colour and black-and-white at the same time?

08

Obviously, if you want to take photos both in black-and-white and in colour, you should really have two cameras if you don't want to have to change films all the time. However, there are some cameras fitted with interchangeable backs which can be quickly removed. Owners of interchangeable lens cameras sometimes prefer to carry a second body, one loaded with colour and the other with black-and-white. Only the well-to-do these days can afford to acquire a second camera, unless it is a modestly priced one.

Never leave your camera behind

09

There's one thing I really must recommend most strongly in this section: on holiday, carry your camera *everywhere* with you! If you see something interesting, get it on film. Delay for a few hours – or even for a few minutes – could mean that the scene will be completely changed. Even where the light isn't good, or where you haven't had the chance to take a reading, don't mess about. Take the picture. If the light is better the next day, come back and take it again. Every photographer has had the experience of seeing a scene which was not snapped immediately being lost for ever.

Photography from moving vehicles

10

Photographs from moving vehicles require a very fast exposure, at least 1/250sec, and preferably faster. Even at this sort of speed, details which are near the vehicle can turn out blurred. It is therefore much better if you can arrange to take your pictures in the direction in which you are travelling. This way, I would say that it is quite possible to take photos in motion. Try to rest your camera on the window-frame or against the glass. Beware, however of taking photographs obliquely through glass, because in this way you can get distortion occurring. In most cases, it is better to lower the window if you can.

Photos from aeroplanes

111

The fact that you can't open the windows of an aeroplane is a real problem for photographers. The thick glass gives all sorts of odd effects, particularly if you are photographing at an oblique angle, and it is not usually easy to avoid them. If you are near a window and your camera has a telephoto which has the least tendency to shake, you'd better forget about the photograph. Only with a standard or wide-angle lens is it worthwhile taking a chance on photos which seem to have a suitable quality. Except for sunrise or sunsets, any scenic motive you come across will have very little contrast. Because of this, you should use a slightly wider aperture for reversal film, and a smaller one for negative film. For the correct exposure of reversal film, you will have to stop down a little more than indicated by the meter.

Give photos instead of flowers

112

It is nearly certain that, during your holiday, you will encounter friendly people who seem to want to help you. How can you thank them for the help or advice that gave you such an interesting photographic holiday? Take a photo of them, and send it on to them after your return. There are few things that cost so little which at the same time give so much pleasure. Not to mention the pride which being able to send them a well-taken photograph will bring you. A Polaroid camera, as a back-up, can be really useful in cases like this. Within seconds, you can present a photo to your new friends!

Local festivals as holiday themes

113

A festival with costumes and dances can be a particularly attractive subject for holiday photography. It is best to enquire at the local tourist office or at your hotel to find out whether, during the time you are staying there, there will be any such activity in your area. Festivals like this are sometimes the only occasions where you find authentic local costumes. And, in the good humour which usually prevails, no one will object to your taking photographs. In this way – and if you try not to attract attention – you will be able to get shots of facial expressions which would otherwise be extremely difficult – if not impossible – to get on film. At times like these, always have your camera at the ready.

Beautiful shapes

No, I'm not talking about what you're thinking about – although they make nice pictures, too! What I do mean is the beautiful shapes and designs that nature puts before our eyes. Reflections of brightly coloured boats in water, flames around logs in a camp-fire, the patterns made by bare tree-roots, the multi-coloured grain in a rock, or the shadow of iron railings on the head of a child. It is only when you are on holiday that you can find the time to look for the beauty of things like this. For the best photographic effects with a standard lens, get as close as you can – about one metre if possible.

Photographing works of art

Holidaying abroad, you're more than likely to come across some little rural church with a beautifully carved madonna, or a town hall with some magnificent old painting.

Shots of this sort are prizes in a collection of photographs and, if you are at all interested in art yourself, you will like taking this sort of picture. Since most of these things will be indoors, you will need a flash and a long extension cable. Study the direction of the light. Gilded figures and paintings need light coming from the side of the camera. Also, remember that the greater the distance your flash is from the subject, the less disturbing will be any accidental reflection in glass or polished surfaces.

Stucco in the Church of St Michael in Hamburg. Taken with 10cm lens, electronic flash with Maxiflash distance reflector (see Section **152**), **from a distance of 25m using Agfa Isopan ISS, 100 ASA.**

Equipment for underwater photography

116

First of all, in order to see under the water you will need a swimming mask which fits well but not too tightly. Don't get a mask with the snorkel all in one piece because, if water gets into the snorkel tube, it also gets into your eyes. Don't get a snorkel tube with a valve, either, because the valveless tube expels water more easily. Fish hear very well! Also, learn to swim gently; the best thing here is to get yourself a good pair of flippers which will allow you to move forward gently while leaving a hand free to operate the camera, which of course you will have placed in a waterproof case for submarine operation. There are several high-quality models available. Finally, while you have to be able to swim to take underwater photographs, you don't necessarily have to be an experienced diver.

Calculation of distances under water

117

Under water, everything seems closer to you than it really is. The refraction of light rays makes, for example, a school of fish look about a quarter of the real distance closer. Fortunately, this has no importance when it comes to setting the camera. It is in this respect exactly the same as the eye, and the distance setting corresponds to the visual impression. The general rule of photography — get close up — applies more than ever under water. Things disappear into a sort of milky soup if you get too far away and, even if you can see them, they acquire a blue colour.

Underwater flash

118

You never use electronic flash under water unless it is specifically designed for the purpose. The illumination depends on the clarity of the water. As a general rule, at distances of about 2m, divide the guide number by three, and again by the apparent distance between the flash and the subject. Don't try to use flash at distances greater than 2m, because it will probably turn out badly.

Using the light meter under water

Put your light meter in a special sub-aqua case or a watertight jam jar (better make sure it *is* watertight by trying the jar out with something less valuable in it first). Use only the middle reading under water; higher ones don't mean very much.

Winter holidays with a camera

In winter sport situations, such as skiing, it is best to keep the camera under your anorak, where your body heat will keep it from getting too cold. Battery-operated cameras, in particular, should be kept from getting too cold, otherwise the switch may operate too slowly and the photograph be over-exposed.

Photography in snow

In snow, the blue sky lightens the shadows, and black-and-white photographs can turn out too light. This can be remedied with an orange filter. In some cases a yellow filter will do the job, but it is sometimes considered too weak. With colour film, the shadows can be darkened with a polaroid filter. As you already know, large white surfaces interfere with the light meter, so that when you come across a wide expanse of whiteness, you should open the diaphragm one stop more than indicated on the light meter. If you use your meter for the blue sky alone, or close to a face, no exposure correction will be needed.

Interchangeable lenses

The number of cameras with interchangeable lenses has increased significantly in recent years. If you are fortunate enough to own such a camera, I heartily recommend that you invest in a telephoto, which will act as a telescope for your camera and, furthermore, will open up for you a whole new series of avenues for picture-making. Perhaps you are surprised that I haven't mentioned a wide-angle lens. Without underestimating its importance, I believe that, as a beginner, you will be far better off with a telephoto. More to the point might be a zoom lens, which gives you a whole range of focal lengths within a predetermined field, for example 80–200mm.

Beware of the dog!

Courage is a very praiseworthy virtue, but a telephoto lens is much safer! Subjects at the far sides of railings, ditches or rivers can be brought within your reach quite safely with a telephoto, or with a zoom lens set at the maximum telephoto position. This is how to take good photos of animals which are too timid — or too aggressive! — to take otherwise. The wide-angle lens, on the other hand, is good for things close to you, and helps by bringing more into your field of view. This can be very helpful in long streets, especially if you want to get a lot of detail in. The standard lens is not usually wide enough for such cases.

Differences between the telephoto and the wide-angle

With a telephoto lens, things tend to look closer together. Heights of mountains and buildings look less. The wide-angle lens, on the other hand, spreads everything out. With its short focal length, the wide-angle tends to emphasize the foreground, producing a great effect in the photo, but at the same time things in the distance look even smaller.

Colour plates on third centre page

Right, top: **Panorama of the Greek port of Kavalla taken with a 21mm lens.** Below: **Details from the same scene picked out with an 18cm lens.**

The telephoto as a portrait lens

Portraits in large format require large focal lengths, but those in miniature format are better with focal lengths of about 85, 90 or 100mm (all of which can be provided by one zoom lens). If you want the head to fill the whole picture, a standard lens requires that you take it from no more than about one metre, and often the face will look distorted as a result. The nose is enlarged and, depending on whether the photo is taken from above or below, the forehead or chin will be emphasized. For a balanced portrait, a distance of at least 1.5m is necessary, but at this distance a standard lens will give you a half-body shot. If you are using negative film, you can of course do a partial enlargement later.

Height reduction with a telephoto

Carvings high up on a castle wall, town hall clocks, weathercocks— these are all subjects which, with a standard lens, you can only take from underneath. A telephoto allows you, without loss of scale, to get far enough away so that you don't have to tilt the camera a great deal. Looking at photos taken with a telephoto, you might think that the photographer had climbed a fireman's ladder to get these themes in close-up.

Distortion with a wide-angle lens

If you use a wide-angle, keep camera tilt to an absolute minimum; better still, do without it altogether. The least tilt of the camera makes vertical lines look askew. Buildings look as if they are going to fall down at any minute. And, talking of buildings, you will find that these inclined lines will clash more than a little when you photograph monuments. Naturally, you can also use this effect for pictorial emphasis.

Colour plates on fourth centre page

Red Square, Moscow, and the Cathedral of St Basil, taken respectively with lenses of 21mm, 50mm and (below, left) 9mm. The church can be taken from closer up with a 21mm lens, but looks distorted (below, right).

Telephoto candid shots

Telephoto lenses are particularly suitable for candid shots. With a standard lens, people know when the camera is pointing at them, and look self-conscious in the photograph. When you are a long way off, things are much better.

In any case, you must still be prepared to make the necessary adjustments and settings quickly. Set up at a time when nothing seems to be happening and, above all, acquire the habit of estimating distances. With this kind of preparation, your victim will not take you by surprise.

Telephoto action shot of fishermen on the Yugoslavian coast.

Candid shots with a wide-angle lens

Candid shots can also be taken at short focal distances. In these cases, naturally, you must get as close as possible to your more-or-less voluntary models, who may well be forewarned of your intention to photograph them when they see you sighting your camera. It is better, therefore, if you can learn to photograph 'blind', without looking through the view-finder. With a little practice, you can master this technique. To be sure, take more than one shot since, of course, the chances of something going wrong are much greater without the control of the view-finder. A wide-angle lens helps ensure that you get everything in.

One other point: there is of course the risk that whatever you happen to have as background will turn out sharp on the photo-graph; to avoid this, you should take up as low a point of view as possible, so as to have the sky as background. The camera on the chest is ideal.

Short exposure times with a telephoto

As you will realize by now, I'm very fond of fast exposures and I've recommended as standard a time of 1/125sec. However, the longer the focal length of the lens in use, the shorter the exposure time needed. So, with lenses of focal length greater than 90mm, take as standard an exposure time of 1/250sec. If you are resting the camera firmly, with your elbows supported on something, you can risk coming down to 1/125 or 1/60, or perhaps take a chance and try 1/30. However, at anything lower than 1/60 you should really use a tripod.

Flash at various focal lengths

If a flash is incorporated into your camera, the focal length in use will also have an effect on illumination. If you use a telephoto, the light will be a long way away from the subject and will therefore give the typical effect of flash at a distance, namely that the subject will be more or less evenly illuminated from foreground to background. If on the other hand you use a wide-angle, you will get the equally typical effect of close-up flash: violently lit foreground and dark background. Naturally, if the theme is the same, the illumination does not change.

Telephotos for photographing fish

If you want to take photographs through the glass of an aquarium (or through windows or display cases, for that matter), a lens of large focal length has many advantages. It allows you to locate your lighting laterally to the camera so that you can see clearly through the glass. Only in this way can you be sure of avoiding reflections. However, the greater the focal length, the more nearly vertically must the light impinge on the glass. Ideally, where possible the light should be over the top of the tank.

Short focal length lenses are very sensitive to reflections. With a telephoto, the possibilities of illumination are much less limited. So long as it doesn't reflect directly, the lighting can be placed exactly where you want it. The only place you must avoid is directly in front.

Flash

When natural light leaves a lot to be desired, flash may be the only weapon in your photographic armoury. However, don't run away with the idea that this is its only use. Its most important function is to make photographs more artistic, more interesting, and have greater impact.

Standard settings for flash

When using direct flash, the effect of the illumination depends on the distance between the lamp and the subject, as well as on the speed of the film. At short distances, the aperture can be very small, while at large distances it will be wide open. The apertures will be indicated on a table usually located at the back of the flash gun. Because of the many different types of flash and film speeds, these are sometimes given in terms of guide numbers, which are divided by the distance in metres to give the aperture. Conversely, dividing the guide number by the aperture gives the correct distance. For instance, with a film speed of 50 ASA, for a given flash the guide number may be 24. The subject is 3m away. So, 24 divided by three is eight which is the aperture you need. If the distance had been 2m, the result would have been $24 \div 2 = 12$. In this case you would have to take f/11 as being the nearest value to that indicated.

X marks the spot

The majority of cameras have a single flash contact, marked with an X, which serves for both electronic and ordinary flashes. There are, however, some which also have an FP flash contact. Ignore this; it is a special contact for special long-peak flashbulbs whose use has been largely superseded. There are various other markings. Some cameras have a bulb symbol, others a symbol representing a flash of light (electronic). Refer to the instruction booklet you got with your camera if you are in any doubt.

High-speed flash

Some cameras cannot be used with flash at a shutter speed faster than $\frac{1}{30}$sec or $\frac{1}{15}$sec. In cameras with an 'X' contact, electronic flashes can sometimes by used at 1/125sec or even 1/250 or 1/500. For important photographs, it is better to try this out in advance. Flashbulbs of type PF1 and AG3B, as well as PFC4 flashcubes, function perfectly well on position X and 1/60 or 1/30sec. Electronic flash depends on the type; some cameras have a top synchronization speed of 1/125sec on the X setting, but do check the instruction booklet for your own camera.

Settings for action shots

When you select flash, many cameras, and notably those with built-in flash, adjust the aperture automatically once you have set the distance. This is, of course, very useful for candid shots. If you do not have this kind of camera, you must prepare your setting in advance. Set the camera to a given distance — say, about 2–3m — and then set the diaphragm appropriately. Before you shoot it is then only necessary to make sure that you are at the right distance from your subject.

The 'computerized' flash — best for action

Electronic flashes with automatic control of the quantity of light — the so-called 'computerized' flashes — can be programmed to select one or more apertures in advance, for instance f/4 or f/5.6, f/8 or f/11. All subjects situated up to a maximum indicated distance will then be correctly exposed. The photographer need only ensure that the image is sharp, and the room-lighting is not too bright. Only extreme light objects can sometimes reflect excessive light. The same is true in cases where very bright reflections interfere with the computer cell of the flash gun.

Background

137

It is often true that too little attention is given to the background when using flash. When it is higher than the camera, shadows can appear on the photograph behind the heads of your subjects. Try, therefore, to get your model well away from any solid background or, even better, against a dark surface, so that any shadows will not show. If all the possible backgrounds are light coloured, try to get your subject against an open window. The backdrop will then be the sky, against which no flash can project shadows!

Outside night shots with flash

138

Anyone who has taken flash photographs outside at night might well have learnt, to his dismay, that the illumination is totally inadequate. This is because outside in the street there are no light-reflecting surfaces. Using flashbulbs or cubes, open the diaphragm one full stop more than the value indicated by the guide number; with electronic, the extra aperture will be from half to one full stop. Outside night shots with flash can be very effective, if you can avoid close proximity to other sources of illumination such as windows, luminous signs, etc.

Flash in the daytime, too

139

Bright sunlight doesn't mean you must leave your flash at home, for it is exactly when the sun is at its brightest, and the sky clear of clouds, that the blackest shadows are formed. Beneath foliage, faces can take on an unpleasant green tinge, and at the same time be speckled with bright spots of sunlight. At the other extreme, in poor weather, your photographs can look greyish and lacking in brightness. In both these cases, you can greatly improve your pictures by using the combination of natural light and flash.

In general, set the camera for the daylight exposure and let the flash contribute only a quarter of the light. Or, ignore the daylight (if it is dull) and expose for the flash only.

Indirect flash

40

You can get a particularly agreeable lighting effect by using your flash indirectly, that is, by directing it upwards at the ceiling. It then reflects uniformly over the subject without casting strong shadows. For the calculation of light intensity, remember that, with flashbulbs, in medium-sized rooms, the guide number must be divided by seven and, in small rooms with light surfaces (kitchens, bathrooms), by five. Electronic flash requires a greater aperture: the guide number is divided by twelve and eight respectively (this is true for reversal film; colour negative film needs more light). But do expose a test film before undertaking an important job.

For colour photographs, especially for transparencies, this method can be used only if the ceiling is white, as coloured surfaces may produce an unpleasant colour cast.

Separate flash guns

41

In general, for candid shots, camera-mounted flash is ideal and enables you to handle the equipment as a single unit. On the other hand, you get a better lighting effect with the flash gun away from the camera, so that the light is from a different direction. A flash extension lead can be obtained from any dealer. In this way, the subject can be illuminated precisely as you want it — from above, below, or from either side.

For portraits of people, you can take as standard illumination a flash held in the extended left hand, so that the light comes from above, and operate the camera with your right hand. An important consideration here is that the illumination is adjusted according to the distance between the flash and the subject; the distance of the camera doesn't matter.

Uniform illumination of a large space

42

A good example of the sort of problem I'm talking about here is a flash photograph of the long table you get at weddings and other festive occasions. This type of photograph is also a good illustration of the natural law that states that the intensity of light diminishes with the square of the distance. So, Auntie Mary in the front will come out with a glaring white face, while cousin Jane in the background looks like she's been on safari. Only the people in the centre of the row will be correctly illuminated. The solution here is a 'teleflash'. Get the light as far away from the table as you possibly can. The flash can be behind the camera if necessary, or well above it. In this way, the illumination will be more uniform, and the chances of Grandma being recognizable will not depend so much on the skill of the processing laboratory. Finally, remember that the distance between the flash and the subject should be ideally at least three times as far as the length of table being photographed.

Disappearing backgrounds

143

It is not always so desirable to have the whole area evenly illuminated. The contrast between a foreground clearly lit, and a background lost in shadows, can at times be very impressive. This effect is obtained by getting the flash as close to the subject as possible, so as to leave the background deep in shadow. In this way you can give even light-coloured walls a grey or even completely black look. If the distance between subject and background cannot be very great for one reason or another, you must make sure that the flash is nearer to the subject than the subject is to the background. In this way, unsuitable backgrounds can be made to disappear!

'Teleflash' for lightening shadows

144

Some photos owe their attraction to heavy contrast. In the majority of cases, however, and especially in colour photos, it is more desirable to lighten the shadows where possible. How to do this? One way is to surround the subject with large, light areas. And if this still isn't enough? Well, if the source of illumination is too near the subject, the light path via the reflecting surface is very much longer than the direct path, and so the amounts of light reaching the subject by these two routes differ greatly. In other words, you get deep shadows. If, however, the source of illumination is moved much farther away, the two light paths are then almost the same length, and so the contrast is less.

Flash as 'footlights'

Faces illuminated from below tend to look ugly and distorted, partly because of the shadows appearing on the upper part of the face and partly because we are used to seeing people lit from above, for example by sunlight. But I do like to use this effect to take caricatures of friends and relations. It's better, of course, if they don't know what you're doing. Then, when they see the results of being lit by 'footlights', they usually find them quite amusing.

Back-lighting effects

Photos taken outside with back-lighting can be very impressive. Back-lit photos with flash can also be very attractive, particularly when the subject is translucent, like flowers, glass, or clouds of smoke. The flash must not be directed towards the lens. A lens hood is always advisable, and particularly so in this case. Using reversal film, particularly with transparent subjects, you should set your aperture at least one stop less than that indicated by the guide number. Negative films need at least one stop more.

Left: **Strong back-lighting. The doll's head hides the light source. Photo taken with six-image adaptor** (see tip **45.**)
Below: **The same picture taken with frontal lighting.**

Silhouettes

You should not confuse back-lit subjects with silhouettes. The former have an outline of luminosity like a halo, but the latter stand out black against a light background. When you want a silhouette, you have to illuminate only the background with the flash. Not a single ray of light must fall on the subject from the front. It is best, therefore, to locate the flash behind the subject. The best set-up of all for silhouettes is with the subject in front of a white, translucent surface lit from behind.

Images in a mirror

I have a particularly soft spot for flash photographs of themes reflected in a mirror. In the normal run of things, these would tend to be portraits. There are two ways of doing this. The first is to have a camera-mounted flash pointing towards the mirror so as to illuminate the subject obliquely. The mirror itself then reflects light onto the model. With this technique, of course, frontal photographs are impossible, since they would have the flash reflected directly back towards the camera.

When setting the focusing distance in mirror shots, remember that you have to include the distance from the camera to the mirror plus the distance from the mirror to the subject. If you focus by screen, this will be obvious.

Photographs through glass

When you use flash for photos of aquaria, windows, display cabinets or pictures mounted behind glass, you often get unwanted reflections. To avoid this effect, point the camera straight at the glass while holding the flash to one side aimed at the part of the subject you see in the view-finder.

This rule is easy to observe if you're using a lens with a focal length greater than normal.

Imitating other light sources

50

If you like experimenting, you might try putting your flash in a table lamp, a lantern, the main lampshade, or even the fireplace, and operating it with a long synchronizing cable.

In this way you get the effect of the original lighting, although its intensity is considerably greater. In this type of photograph, according to the intensity of the flash, you may have to stop down to f/16 or even f/32. Again, as the edges of the illuminated zone will look very dark, it is often advisable to use a second flash as fill-in.

Flash over long distances . . .

51

Using a very sensitive film, a camera with an f/2 lens and a flash with a big PF100 bulb, you can get a guide number of nearly 400. Dividing this by two for the aperture, you can see that, in theory, it is possible to reach 200m with a flash. This would, however, be possible only if the photo was taken in a very large hall, since guide numbers are compiled with interiors in mind, on the basis that half the light reaching the subject does so via reflection from walls and ceiling. Outside, the flash therefore only produces half this amount of light, which means that the aperture must be opened up by one stop, or that the distance be reduced by a third. In other words, the guide number or the distance must be divided by 1.4. In the case quoted above, however, this still means that the flash would reach a distance of over 144m.

. . . and even longer distances

52

There are one or two 'teleflash' electronic units made, such as the French Maxiflash and the Minicam teleflash. These outfits have an adjustable reflector which can be used to concentrate the beam to illuminate a distant subject when you are using a telephoto lens. However, if you want to illuminate a large area, such as an architectural interior, and you have an ordinary small flash gun, you can still do so. The trick is to wait until it is dark, mount the camera on a tripod, open the shutter on B and fire off several flashes by means of the manual button on the flash gun. The flashes can be aimed at different areas, say, one for each wall, two for a high ceiling and two for the distance. This is some-times called 'painting with light'.

Synchronizing several flashes

There is an accessory available by which you can quite easily operate several flashbulbs simultaneously. This consists of a distributer box by which cables from two or more flashes can be brought together and connected to the camera. But here is a word of warning: before connecting them up, you must ensure that all the bulbs are in place, otherwise there is a danger that the bulbs might go off as soon as the plug is put in. This danger indicates the need for disconnecting all the cables after each photo, changing the bulbs one at a time, and reconnecting.

To use the flashes individually, it is only necessary to disconnect the connections.

Extra bulbs with electronic flash

Some electronic flashes are equipped so that one or more extra lamps can be connected to them. But to couple up a normal flash with an electronic is foolish; all attempts of this type are doomed before they begin. Several electronic flashes can be connected up with the right type of accessory but, unfortunately, the camera's synchronizing contacts suffer from this type of experiment if it is done very often.

Multi-switch cameras

In cameras equipped with two synchro sockets, it is easy to connect up two lamps, one of which may be an electronic and one a normal flash (using contact X).

There is no point in connecting an electronic flash to both connections. In the photo it will be seen as only the effect of the flash connected to contact X.

Extra lamps with photocells

Modern photocells present a perfect way of setting off secondary flash units of either type without the use of wires. The light of the flash on the camera sets off the others by means of photocells connected to them. These so-called 'slave units' can be set at any reasonable distance.

Leila, a Long-haired Dachshund, illuminated with two electronic flashes, one fixed to the camera and the other, operated by a photocell slave unit, used to light the background.

Flashes pointing in the same direction

If you have two flashes pointing in the same direction and located at the same distance from the subject, you can reduce your aperture by one stop, or increase your distance by 50%. In other words, you multiply the guide number by 1.4. With three lamps, the aperture can be closed down by $1\frac{1}{2}$ stops, your distance away increased by 77%, or the guide number multiplied by 1.7.

Using four lamps, aperture goes down by two stops, and distance and guide number are doubled.

Main and lateral illumination

When you use one lamp as the main illumination and a second, or even a third, as supplementary lighting, you must concentrate all your attention on the main one. The secondary lighting affects the contrast, lightens the shadows, but does not affect the main illumination.

Any disagreeable effects can be eliminated by making the secondary illumination reflect from another surface, or by softening the light, for example by a gauze over the reflector. The flash which is going to be used for this purpose can be located on the camera. The main illumination should be independent of the camera and operated by a cable or photocell slave unit.

Lamps at 45°

With a subject illuminated by two lamps of equal power set at 45°, the aperture can come down by half a stop and the guide number can be multiplied by 1.2. Both lamps must of course be the same distance from the subject. If one is closer, it will then act as a main illumination, with the other as secondary.

Using several 'computer-flashes'

If you arrange several computer flashes (see **136**) around your subject, with one closer to act as the modelling light — you won't get the effect you imagine. This is because the lights will combine, as the power given by each will be influenced by the others, and the result will be dead flat lighting. The trick here is to set the camera lens and the main flash correctly, but alter the subsidiary computer(s) to twice the correct ASA setting. The subsidiaries will then work on half power. Alternatively, use the flashguns on manual and arrange as you would ordinary studio lamps.

Photoflood

At one time, indoor photography was more difficult than it is today, mainly because there were no high-speed films. It was at best difficult, and at times almost impossible to take good photographs with artificial light.

These days, however, we can take good action shots with a single lamp. There are small lamps of 1000 watts which are very easy to handle; using these with colour film of 50–80 ASA, or black-and-white film of 100–160 ASA, all the problems of artificial-light photography can be eliminated.

Photographic bulbs

At first sight, the 250, 375, or 500 watt photofloods with built-in reflectors look like good value. In comparison, the 1000 watt halogen lamps look relatively costly. On the other hand, you must remember that the halogen lamps have a life of about fifteen hours, compared with about three hours (for the 250 watt), four hours (375 watt), or six hours (500 watt) for conventional bulbs. Then again, there is another consideration: to match the light output of a 1000 watt halogen lamp, you would need at least three conventional lamps. As you can see, halogen lamps have a lot to commend them, and I have no hesitation in recommending them to you. Although there are 650 watt halogens, I would advise you to get the more powerful kilowatt version.

Table of values for Philips photofloods				Colour temperature (°K)
Type	Power	Light output	Life (hours)	
Argaphoto B	500	11000 lm	100	3200
Argaphoto BM[1]	500	5500 cd	100	3200
Argaphoto	1000	23500 lm	100	3200
Photolita S	250	7500 lm	3	3400
Photolita SM[1]	250	3300 cd	3	3400
Photolita KM[1]	375	13000 cd	4	3400
Photolita N	500	14500 lm	6	3400
Photolita NM[1]	500	8000 cd	6	3400
PF 800R[2]	1000	33000 lm	15	3400
PF 810R[2]	650	20000 lm	15	3400

1. with internal reflector, 2. halogen lamp.

Advantages of halogen bulbs

Apart from their luminous intensity, halogen lamps also have the advantage of ease of handling. They are very light, and can easily be carried in the hand or fixed to tripods, etc, even when they are not very firmly supported. It is possible to carry three or four of them around without much difficulty. The other advantage is of great interest to the photographer who wants to use artificial light a lot: light output and colour temperature stay absolutely constant throughout the life of the bulb. This is in contrast to ordinary bulbs which, as they get older, suffer a loss in intensity and a reddening of their light.

A compact 1000 watt halogen lamp is ideal for indoor photography

Artificial-light film

With artificial light of a basic red-yellow tone, the usual sort of black-and-white film (panchromatic) transforms reds and yellows into light tones which are not proportional to the originals. To intensify the reds of lips or the pink of cheeks, for example, a green or blue filter would be used. With colour negative film, you can use only the type marked 'universal', or that intended exclusively for artificial light. The colour negative films balanced for daylight can be used only with a conversion filter. As you might think, the type marked 'artificial light' is specifically intended for use in ordinary artificial light. If you use a halogen lamp, therefore, you will get much better results if you use a pale pink filter (R1 or Skylight).

Conversion filters

Daylight-balanced films can be adapted for use with artificial light with a conversion filter of a warm colour (R12). If the sun is shining through the window, however, there is sufficient light, and a little more or less makes no difference.

Electrical connections for several photofloods

You can, if you wish, connect up several halogen lamps, or even mix them with ordinary lamps. With a 6-amp circuit, you can have 1320 watts (at 220 volts; remember, watts = volts × amps), which would allow you two 650 watt or one 1000 watt halogen. Fortunately, most circuits will take 10 amps, which will let you have two 1000 watt lamps, or three 650 watts, or one 1000 watt halogen and four 250 watt conventional lamps. At times like this, though, when you are up near the limit, you must make sure that all other current-consuming devices are switched off (don't forget the fridge, for example). It is usually best to use more than one circuit, which allows you to go up to five or six kilowatts if required.

Sunlight through a window

The one kilowatt halogens are so powerful that a little light coming through a window will make no difference. Of course, if you're worried about it, close the curtains. But I think that the contrast between the interior lit with artificial light of a precise colour temperature and the bluish exterior, lit by artificial light, gives the sunlight a bluish tone, while the daylight gives the artificial light a red-yellow tone.

Close-ups

Any camera can take close-ups with the proper lens attachment fitted. And it is really worth the effort and expense, because there can be no doubt that macrophotography is one of the most interesting things you can do with your camera. I advise you to try it as soon as you can. Each minute subject, whether it is a flower, a beetle or an insect, a bobbin of thread, plant roots, or whatever, are things which, in an unexpected way, have a fantastic effect when they are projected a metre or so high and in full colour.

What you will need

167

Normal cameras aren't adapted for close-up work, so you will need some special accessories. Even the simplest camera will take a close-up lens. Distances can be measured easily with a graduated ruler. In this case it is advisable to mount the camera on a tripod. Even better are the special close-up range-finders which are available, or setting marks which can be mounted on the camera. If you have a reflex, of course, you won't need any of this, because you will be able to see through the view-finder whether or not the image is sharp. Extreme close-ups cannot be taken with the normal close-up lenses. The majority of reflex cameras permit this level of magnification by using interchangeable bellows or extension tubes, but this is coming within the definition of macrophotography.

Sharpness in macrophotography

168

While conventional photography doesn't demand extremes of sharpness, macrophotography insists that all the details of the image must be reproduced with absolute sharpness. Because of this, in black-and-white, you should choose the most sensitive possible film. Choose an aperture of, say, f/8 or f/11, so as to get a greater depth of field. Remember also that the accessories (bellows, extension tube, etc) tend to have an effect on the amount of light transmitted, equivalent to stopping down somewhat. Again, you should always use a tripod. The depth of field is so short that manual focusing is very difficult, and a large lens aperture doesn't make it any easier.

Lighting for high magnifications

The size of the bellows can cause a considerable loss of incident light. A focal length of 1.5× (magnification 1:1.5) requires that the exposure time be increased by a factor of 2.3. When the focal length is 2× (1:1), exposure must be increased four times, and when it is 3× (2:1), nine times. You can see then, that if, say, for a photo at 1:1 the aperture is f/8, you will only just get the same amount of light coming in as you would at f/16 under normal magnification. Naturally, through-the-lens metering solves this problem. At large magnifications, therefore, it is sometimes necessary to have quite long exposures. If you want to take moving subjects, like insects, the exposure time must be reduced by increasing the illumination.

Reinforcing daylight

To obtain better illumination, or simply to lighten shadows, we can as it were, amplify incident daylight by using aluminium foil or small mirrors. With a shaving mirror, which is usually relatively large, you can get a considerable increase in incident light and, as a result, a reduction in exposure time. It is also possible to direct sunlight onto a small object.

Reflectors, mirrors, etc, have a greater effect in illumination of close-ups than they do in conventional photography. To lighten the shadows on a group of people it may be necessary to use a large sheet; for a flower, or a small painting, a handkerchief may be all that's necessary.

Artificial light

With a photoflood, you're no longer dependent on sunlight, but only on the electric mains. The 1000 watt halogens already mentioned are quite suitable for close-up work. They are so powerful that they can be situated a good way away from the subject, thus avoiding over-heating it. At the same time, the shadows will be sharp, but not hard; this is especially good for photographs of relief, and can be even better with a reflector which enables the light to be set as far away from the subject as possible. Of course — and this recommendation applies equally to flash — light need not only come from the front, but also from the sides, from above, from below, or from behind.

Lighting reflective objects

Reflective objects, like silverware or porcelain figures, require an especially soft lighting without reflections. The best way is to surround your subject with pieces of glass covered with transparent paper, with the lighting behind it, so that you have a sort of illuminated screen around it. You just leave one space for the lens to go through, and use three or four lights to get the most even illumination you can. If the lighting is then too soft, make a gap in the screen through which some light can get to the subject.

Close-up of a wasp in a recently completed nest. Taken with a 100mm Macro Elmar. Because the depth of field is so short, only the head appears sharp.

'Dark field' and 'light field' illumination

Many objects, especially flowers, look far better when light passes through them. With the type of illumination called 'light field', they are illuminated from behind a sheet of opal glass, or a sheet of plain glass covered with translucent paper. Those parts of the object which do not transmit light look dark, while the other parts shine with transmitted colours. Even more fascinating is the technique called 'dark field'. Here, the object is placed upon a sheet of glass, which is set at a certain distance away from a dark background of, for example, black velvet or wrapping paper. Above the black surface are placed one or two lights which shine on the subject through the sheet of glass. With this type of illumination, you have to be careful that the light from the lamps doesn't shine directly into the lens.

Close-up flash

Flash is the ideal form of lighting for close-ups because it guarantees sufficient light. However, guide numbers are valid only for distances greater than about 1·5 to 2m which means that you are going to have to experiment a little with close-up flash. As a general rule, between 1.2m and 0.69cm, open the diaphragm one stop more than the guide number indicates. At distances less than 60cm, try half of the indicated value. You will also have to take into account the variations in exposure times caused by the bellows or extension tubes you're using. Close-up lenses don't require any extension. If the flash is very close to the subject, the majority of the light will go straight past it; you can use a tube to direct the reflector towards the subject.

Photographing living creatures

I can tell you from experience that it isn't at all easy to take a close-up of an insect, for example. This type of theme almost invariably requires the use of flash. The lenses and extensions you have to use are very bulky, but you cannot take the photograph at all unless you can get really close up. With bees, it is better not to get too close, however. They can more easily be photographed in the early morning, when the cool air and the dew tend to slow them down somewhat. Butterflies are attracted by the nectar in certain flowers, and you can take advantage of this by setting up your tripod, focusing exactly on the flower, and waiting patiently to see whether your model is going to put in an appearance — or not, as the case may be! It is probably best, with your first attempts at photographing small creatures in close-up, to choose fairly slow-moving targets, like snails and caterpillars.

Reproduction

You can of course reproduce photographically pages or pictures from a book. You should use between two and four lights. If you use a single light — flash, for example — you will get a better and more uniform illumination if you get it as far away from the page as possible. In this way you can, without a great deal of difficulty photograph colour reproductions, water-colours, or even postage stamps.

Projection

It goes without saying that you show only your best slides. So it is common sense to match the care you have taken in preparing the photographs with an equal care in projecting them. When you have read the following tips, you will realize that you have several choices when it comes to projecting your slides. For example, you can decide whether you want to project normal size, or go for big enlargement. The choice depends partly on your taste, and partly on the capacity of your projector. Whatever you do, bear in mind that overall image clarity is more important than size of projection.

Subdued lighting

Ten minutes or so before your session is due to begin, dim the room-lighting a little. By the time your show starts, the audience's eyes will have become accustomed to the subdued lighting, and the slides will therefore look brighter. If on the other hand they are forced to walk straight from bright room-lighting into total darkness, the first few slides are bound to look rather washed out. Keep the room in darkness during projection, of course. And don't forget to fill their glasses before you begin!

Normal projection

There is a very common tendency to project slides as large as possible at the expense of clarity. The rule is that the diagonal of the image should be about one quarter to one sixth of the distance from the audience to the screen. At this distance, the slide can comfortably be viewed all at once. A correct projection always looks good. Wide-screen projection (see next para), which falls outside our breadth of vision, gives a completely different effect.

Wide-screen projection

Powerful projectors can blow up an image to a considerable size without loss of luminous intensity. If you are in a relatively small room and you project an image, say, three metres across, it will extend beyond the normal angle of vision. The image then seems to surround you, as it would in real life, and this can give a tremendous sense of space, as if you were actually in the picture itself. Of course, you can only do this if you are projecting rectangular slides. The effect is even more impressive when using large format slides, as we shall see in the next paragraph.

The illusion of space

The optimum sensation of space occurs when a photo, in the context of its composition, is viewed or projected according to the theme. In other words, when it is seen from the same angle as it would have been in real life. This depends on the focal length of the camera lens, the magnification of the projected image, and the distance between the screen and the audience. The precise relationship is as follows: the focal length in centimetres multiplied by the magnification is equal to the distance in centimetres. As a result, photos taken with a wide-angle lens need the maximum possible enlargement, while those taken with a telephoto can be projected with a relatively small magnification for the same viewing distance.

Image clarity

A slide must never be projected too faintly and, in particular, the best colour effects depend on perfect illumination. If you are not sure whether the screen will be sufficiently light, use a light meter to measure the light reflected from a blank screen illuminated by the projector without a slide in it. Set the light meter to 50 ASA and the aperture to f/2.8. If it reads 1/10sec, the screen is light enough for black-and-white; for colour, you will need to get a reading of 1/10sec at f/4. If you can't get the right reading, then you must change the relative positions of projector and screen and be satisfied with a smaller image, or change to a more powerful bulb in your projector. Remember — always go for clarity rather than size when you're projecting slides.

The screen

One factor that can make or break your showing is the quality of the surface you use as a screen. A sheet, for example, will never be as good as a proper projection screen. What happens is that some light passes through the sheet and is reflected back by the surface behind it. This dispersed light plays havoc with your image quality and, of course, you don't get this effect with a proper screen, or even with a flat white wall.

Keep it short!

An awful lot of slide shows suffer from one terrible defect — too many slides! It is quite understandable, of course, that photographs into which you've put your heart and soul do tend to have a reducing effect upon your critical faculty. But you must remember that your audience has no such memories, and soon runs out of patience. Your photos will never recall for them the memories and experiences they do for you. So you must be hard on yourself, and put away any slide that has a technical fault which would require explanation. And, as a rule, 50 to 60 slides projected over half an hour or so is ample, both as to number of slides as well as to time. Your audience will be grateful for your consideration.

Colour intensity

As we've already learnt, slides taken in the early morning, in the evening, and with flash tend to be 'warm' in colour, while those taken in the bright sun of midday are rather 'colder'. You should therefore mix these slides during a showing so that the contrast between the different intensities of colour gives impact to the display. As you pass from one type of colour to the other, you can intersperse slides which have both, as a sort of lead-in.

Back-lit slides

If the subject has a lot of transparent surfaces, back-lighting can produce some very colourful effects. In the majority of cases, however, they produce rather washed-out colours and, because of this, they should be projected in between slides of very high contrast. The jump from a warm to a cold colour balance, as described above, can be softened by the interposition of a pale back-lit shot. You should aim to build up a collection of all sorts of shots, including back-lit ones, so as always to be able to produce a balanced selection.

Back-lit shot of the port of Hamburg. There is very little colour in this slide, which makes it ideal between two others whose colours are completely different.

Alternative formats

The 6×6 or 4×4cm square format slides can be a little boring, and any slide show can be a lot more interesting if there are several changes of format. Normally, this would only mean changes from horizontal to vertical. However, you can also ring the changes by taping dark strips to the edges of your slides. In this way, you can add even more interest by interspersing among your normal slides some framed into hexagons, ellipses, circles, or indeed any other shape you find appropriate.

Slide sandwiches

At times, I like to show two slides at once. For this, one at least of the two slides in question must have a very light-coloured background which will be almost completely transparent. This 'sandwich method' also requires that one of the pictures is the opposite way round, because you have to put the slides into the mount front to front so as to ensure that both images are in focus. An example of how this effect can be used is to have one slide which is a silhouette framing a picture which is suitably positioned on the other.

Highlight of the evening — moving pictures!

Yes, moving pictures! This can be done in rather the way a 'travelling' movie shot is made. For this, you need to be able to adjust the focus of your projector manually. You also need three successive slides of the same moving theme, which should have a light background. You then mount them suitably, and put all three in the projector at once. You arrange for the focus to be initially on the first one, and then you change focus to the second, and finally the third. Put in at the end of a showing, this effect is guaranteed to bring out the applause. It is amazing how such a simple trick has such a surprising effect.

Always have a spare lamp

One of the most stupid things that can happen is to be half-way through a showing and have to abandon it because the projector lamp burned out and you didn't have a spare. Ask yourself now — have you got one? If not, take the advice of one who has learnt the hard way: go out and buy one. Or preferably two!

Sound

Whether you like it or not, there has to be some sort of commentary during a slide show and not everyone has the gift of the gab. Also, it can be more difficult to speak to a small gathering of friends than to a whole roomful of people. So think of the convenience of having a ready-made sound track for your show — that way, you can put in music, too. Nothing has quite so much effect on the audience as the right combination of image and sound.

Using records

A collection of slides can be backed up with sound, even if rather crudely, simply by using a record. Just put on a suitable LP. You may not need a commentary. If you don't want to talk over the music, just limit yourself to the few remarks necessary to put the display into perspective. Ideally, the selection may not need anything more than just the music. If you're showing holiday slides, simply slip in the odd slide of a place name, or pass around some tourist literature in advance of the showing. You may not have to say a single word. The music will fill in all the atmosphere needed.

Tape or cassette?

You have a choice between reel-to-reel tape or cassette, nowadays. One is more flexible, the other more compact. With a four-track reel-to-reel set-up, you can have music on one track and commentary on the other. Then you can have them both together, or separately. In some cases, you can even control them separately. On a spare track you can even have recorded impulses that can change the slides via an autochange machine. Some cassette recorders can incorporate an autochange facility; with these, both music and commentary are on the lower track, while the upper track, which would normally be the 'flip side', carries the autochange impulses. This facility is built into more sophisticated projectors.

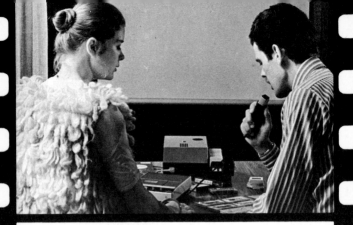

Manual slide-changing

192

You can put both text and music on a single tape. If you don't happen to have the necessary apparatus to project automatically, however, you can always do it manually, changing the slides on prearranged cues in the words or music. You've got to know your script to do this, and it is a disadvantage of this sort of arrangement that mistakes are quite easy to make if you forget your cue – which can happen if some time has elapsed since you first made the tape. If then you want to make the tape into a fully automatic commentary, you have only to record on it slide-changing impulses at the right places. I say 'only' because I think you will not find this difficult.

Automatic projection

193

For automatic projection, you need, in addition to the projector and the recorder, the equipment for recording the impulses which change the slides. The process is as follows: the sound-track tape passes over the head of the control box, which is connected to the projector. Some projectors have this facility built in. If the equipment is set on 'record', you only need to press the button which changes the slide, and at the same time sends an impulse to be recorded on the tape. When you come to do the projection, the recorder is set on 'playback', and the impulses trigger the slide-changing mechanism. And they don't forget!

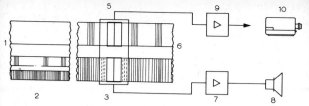

Schematic of synchronizing system. **1.** Magnetic tape. **2.** Stereo tracks. **3.** Mono tracks. **4.** Sound head. **5.** Impulse head. **6.** Impulse track. **7.** Sound amplifier. **8.** Loudspeaker. **9.** Impulses amplifier. **10.** Projector.

Agfacolor 250 slide projector, with Agfaton impulse generator, connected to a Philips N2209 AV cassette recorder; an ideal set-up for automatic projection with sound.

Silence is golden

The golden rule for a slide show with sound is – a lot of music and not much chat! Only say what you have to. Keep your sentences short and to the point. There are two possible methods: give a brief commentary on each slide, or just say a few general words as illustration. It doesn't help to tell your audience about things that don't appear in the slides – '... and just there to the left (well, you can't see it actually, it's round the corner) is the hotel we were staying at ...' Or '... and you see there, where the sunlight strikes the foot of the mountain? Well, I had a look through my binoculars and there was a genuine mountain goat ...' This sort of thing will only get the audience's goat! You'd do much better to play music!

Music keeps it moving

You should, of course, choose suitable music: Tyrolean tunes for alpine scenes, Italian arias for Rome or Naples. Light classical music is often best for scenes which don't suggest any particular theme. You could, for example, choose the theme from Smetana's 'Vltava' to accompany shots of a majestic river. However, you should be careful not to vary the music too much, or to choose too many contrasting themes, otherwise you will just end up by irritating your audience. You shouldn't really vary the type of music over the whole series of slides.

Don't try to be funny

Don't, I beg you, please, try to put jokes into your script! You may be able to reduce an audience to fits of laughter with the force of your personality, but doing it on tape is something else. Even professionals don't find this one easy. The results can be downright embarrassing on replay; so I repeat, don't do it.

Get the style right

A common fault in your early sound tracks will probably be attempts to get too much in. This might be all right with film, but not with still pictures. You should also avoid any tendency to speak for the people appearing in the slides. With cine and TV, we are used to lip-synch, but with slides the effect can only be comic, or painful. For the same reason, don't go 'Moooo!' if you have to show a picture of a cow. If you show a mountain scene of cows in the pasture, it might be quite appropriate to have the sound of cowbells, however. The audience might not notice the clash between the still image and the 'moving' sound in this instance. But again, the golden rules are: keep it short; speak as little as possible; few sound effects, and then only in the right place; and plenty of music.'

Donald Duck voices

A tape-recorder with three or four speeds can give some funny effects with voices. For example, if you play back a voice at a higher speed, it sounds like Donald Duck. You should of course speak much more slowly on the original recording if you want the words to be distinct. You can also get a deep croaking voice by playing it at half the recorded speed.

Recording by cable

You musn't forget this important point. If you want to put music from a record or from the radio onto a tape, you don't need a microphone. All record players and most radios have a special socket from which it is possible to record direct by connecting a cable from it to the recorder. With care, this can give you excellent results.

Small is beautiful

Finally, a repeat of tip number **183**. Because I think it so important, I give you it again to finish off with. Don't let your showing run for more than half an hour, in which time you can show some 50 to 60 slides. Of course, you'll want to show off all your favourite slides, but the overall effect is more important than the individual details. Include only your very best slides, keep the chat to a minimum, and everything will be fine.

Tailpiece

That only leaves one more thing to say — that I hope I have given you the tips you wanted. This book is by no means an exhaustive treatise on photography but, if I've covered the main points of black-and-white and colour work, I shall have done what I set out to do. I hope you find it useful, and that you'll get some great photos.

Günter Spitzing

Other titles in this series:

E. Voogel and P. Keyzer

200 ciné tips
200 colour tips
200 darkroom tips —
black and white
200 photoflash tips

Jan van Welzen

200 darkroom tips — colour

For a full catalogue of
Fountain Press photography
books, please write to
Argus Books Ltd, 14 St
James Road, Watford, Herts,
England